Ingmar Bergman,
Cinematic Philosopher

Books by Irving Singer

Ingmar Bergman, Cinematic Philosopher: Reflections on His Creativity

Cinematic Mythmaking: Philosophy in Film (forthcoming)

Philosophy of Love: A Partial Summing-Up (forthcoming)

Three Philosophical Filmmakers: Hitchcock, Welles, Renoir

Sex: A Philosophical Primer, expanded edition

Feeling and Imagination: The Vibrant Flux of Our Existence

Sex: A Philosophical Primer

Explorations in Love and Sex

George Santayana, Literary Philosopher

Reality Transformed: Film as Meaning and Technique

Meaning in Life:
The Creation of Value
The Pursuit of Love
The Harmony of Nature and Spirit

The Nature of Love:
Plato to Luther
Courtly and Romantic
The Modern World

Mozart and Beethoven: The Concept of Love in Their Operas

The Goals of Human Sexuality

Santayana's Aesthetics

Essays in Literary Criticism by George Santayana (editor)

The Nature and Pursuit of Love: The Philosophy of Irving Singer (edited by David Goicoechea)

Ingmar Bergman, Cinematic Philosopher

Reflections on His Creativity

Irving Singer

The MIT Press
Cambridge, Massachusetts
London, England

MIT Press books may be purchased at special quantity discounts for business or sales promotional use. For information, please e-mail special_sales@mitpress.mit.edu or write to Special Sales Department, The MIT Press, 55 Hayward Street, Cambridge, MA 02142.

This book was set in Palatino on 3B2 by Asco Typesetters, Hong Kong, and was printed and bound in the United States of America.

Library of Congress Cataloging-in-Publication Data

Singer, Irving.
Ingmar Bergman, cinematic philosopher : reflections on his creativity / Irving Singer.
 p. cm.
Includes bibliographical references and index.
ISBN 978-0-262-19563-8 (hardcover : alk. paper)
1. Bergman, Ingmar, 1918–2007—Criticism and interpretation.
I. Title.
PN1998.3.B47S56 2007
791.4302′33092—dc22 2007000645

10 9 8 7 6 5 4 3 2 1

To the memory of Charles Brenton Fisk

Contents

Preface

Since this is a book of reflections on Ingmar Bergman's creativity, it seems fitting to begin with a statement that he himself made about its frequent emergence out of a "seed" in his experience:

Most of my films have grown—from some small incident, a feeling I've had about something, an anecdote someone's told me, perhaps from a gesture or an expression on an actor's face. It sets off a very special sort of tension in me, immediately recognizable as such to me. On the deepest level, of course, the ideas for my films come out of the pressures of the spirit; and these pressures vary. But most of my films begin with a specific image or feeling around which my imagination begins slowly to build an elaborate detail. I file each one away in my mind. Often I even write them down in note form. This way I have a whole series of handy files in my head. Of course, several years may go by before I get around to transforming these sensations into anything as concrete as

a scenario. . . . My films grow like a snowball, very gradually from a single flake of snow. In the end, I often can't see the original flake that started it all.[1]

Writing about the origin of *Cries and Whispers*, Bergman describes a persistent but wholly isolated image that kept coming back to him for more than a year without his knowing why: "over and over: the room draped all in red with women clad in white. That's the way it is: Images obstinately resurface without my knowing what they want with me; then they disappear only to come back, looking exactly the same."[2] In several interviews he has said that the creativity in his directing of film or theater relies mainly upon his momentary intuitions rather than any fixed or premeditated reasoning.[3]

The book you are beginning to read might seem to run counter to that approach. It is written as an investigation by a philosopher into both the meaningfulness and the technical expertise that pervade Bergman's film production. I do not see any contradiction between my procedure in this and his description of his "intuitions." They are the spontaneous flourishing of many years of maturation in his art form, many years of trial and error in molding creative possibilities that lend themselves to cinematic treatment. Reason, or even meditation, enters

into that, albeit in the oblique and beneficial manner that art allows and sometimes requires. I view Bergman as a kindred spirit, and as one who is philosophical in the expanded use of this term that I invoke in the general observations that follow.

My book is a kaleidoscope, a shifting conglomeration of insights and speculations that hew closely to my own experience of the forty-odd Bergman movies I discuss. Throughout my text no pretense of completeness exists, and at times my remarks may even seem to lack order or coherence. That is because the themes and motifs that I study often occur as scattered, and greatly diverse, components of Bergman's films. The structure in my endeavor is not determined by the chronology of the different movies, or any exhaustive account of their individual narratives, or even their detailed relation to Bergman's personal life as distinct from his aesthetic and cinematic development. As I learned from Proust's pervasive methodology, the contextual flow of one's thought can yield a harmonic pattern that may be as important as any systematic assertions one might offer.

Those who want a more conventional kind of introduction to Bergman's career can easily find it elsewhere. I have tried instead to make a presentation that yields a portrait of the filmmaker as an evolving artist, with the many modulations that involves. The chapters are a

running commentary on the meanings and techniques that have elicited interpretive ideas of mine through which I could respond to them. At the same time, my remarks are not purely subjective or impressionistic. The judgments I formulate, both critical and factual, always lend themselves to confirmation or rebuttal. Eliciting a reaction pro or con is indigenous to the communication I wish to establish.

I have dedicated the finished product to the memory of Charles Fisk, the renowned builder of pipe organs in the baroque style, not only because he shared Bergman's love of the music of Johann Sebastian Bach, but also because I feel that if he had lived long enough he could have appreciated and understood, more fully than most others, its great contribution to the flowering of Bergman's genius. Among the people who have read early drafts and encouraged me in this work, I single out Richard A. Macksey and Josephine Fisk Singer.

I. S.

General Observations

In a book he published in 1972, John Simon states: "Ingmar Bergman is, in my most carefully considered opinion, the greatest film-maker the world has seen so far."[1] Since then the world has seen much more evidence of Bergman's extraordinary talent as director, screenplay writer, and sometimes producer of unmatchable movies in various genres. His novels, partly autobiographical; his critical statements; and his own stage plays as well as the many others he directed also contribute to his massive output. Almost single-handedly he created a renaissance of Nordic cinema that has exceeded even the work of Victor Sjöström and Mauritz Stiller, his heroes in early film production in Sweden. Nowadays, despite their reputation, their movies are largely forgotten or ignored. Bergman's will continue to grow in worldwide importance for many decades.

In the more than sixty years of his career, Bergman not only went through different periods in his creativity, as most artists do, but also developed continuously from beginning to end. Not all geniuses or highly productive people are of that sort. Many flash across the sky or suddenly destroy their talent in a burst of energy like the supernovae that they are. Though Bergman escaped this peril, his newer films have sometimes been misconstrued by people who don't realize how original and how varied they tend to be. Other viewers remain unaware of the integral and organic progression that exists from Bergman's earliest films to others that are fairly recent. As I argue in my text, his final motion pictures constitute highly advanced resolutions of themes that preoccupied him throughout the preceding years. In that respect they serve as a model for what artists in any field may hope to attain, if only they persevere and the world allows them to continue unabated.

For those whose progress is as gradual and as subtle as Bergman's was, this great endurance can also be a disadvantage. Film audiences, particularly reviewers who have little time to reflect on their experience at the movies, are prone to assume that the master is merely rehashing insights and techniques with which he has already regaled us. If we wish to savor what Bergman

has accomplished, any such assumption must be discarded in advance.

By providing a panoramic approach to Bergman's films in terms of recurrent themes and motifs that express his particular perspective on the world, I try to show how one might avoid that mistake. At the same time, I make no claims about the uniqueness of my attempt. Many books and essays on Bergman, some of them excellent, have now appeared in print. I will be referring to a few of them. Being a humanistic philosopher and applied aesthetician, I sought in Bergman, as in other filmmakers that I have already written about, a mode of intellectual probing and penetration that seems to me clearly philosophical, though not the same as specialized investigations that belong to philosophy proper.

Apart from any unfortunate efforts to duplicate what trained philosophers do, films we consider great are philosophical insofar as the meaningfulness they embody, and the techniques that convey their type of meaningfulness, exploit at a significantly deep level the visual, literary, and sonic dimensions of this art form. A similar distinction between philosophy and the philosophical may apply to all great art, and to its ability to attain an expressive and purely aesthetic truthfulness

about the world. Studying these achievements of the
human spirit can also help us explain what is art itself,
and the individual character of each art form.

I proceed on the assumption that it is no longer
necessary to argue that film has aesthetic qualities on a
par with the older and more traditional modalities.
Moreover, some filmmakers, and Bergman especially,
retain throughout a faith in the aesthetic potential of
their movies as opposed to any investment value they
may need to have in order to be distributed to an
appropriate public, or even to get produced. To thrive
financially, to succeed enough for one to go on making
more and better movies—all filmmakers must cope
with this double nature of their profession, like Janus
facing simultaneously toward both the commercial and
the purely artful. Orson Welles, for one, and Preston
Sturges, for another, were unable to flourish under this
constraint in the way that Bergman did. He is an exem-
plar of someone who begins as a cog in a studio system
that largely nurtured him as a moneymaker but even-
tually yielded to his wider capacity as a cinematic mas-
ter. The dynamics of that process show themselves in
the evolution of the philosophical ideas that make his
films insightful inquiries into what men and women
feel and think and do as the human beings they happen
to be.

The director David Lean is reported to have once asked Bergman, "What kind of crew do you use?" "I make my films with eighteen good friends," Bergman said. "That's interesting," Lean replied. "I make mine with 150 enemies."[2] Year after year Bergman worked with a company of collaborators that remained more or less the same on successive films. Much of the time he was directing stage plays during the fall and spring with actors who then spent their summers performing in one or another of his films. This situation is comparable to the one that Jean Renoir tried to establish in the productive communes that were devoted to the making of his movies. Moreover, Bergman could benefit from the relative isolation of Swedish society. His eighteen friends were mainly Swedes who lived in or close to Stockholm and often in housing that centered around the theater or film studio in which they worked.

Bergman began his career as what he called a "slave" who edited the film scripts of others. As Sturges had done in Hollywood, he managed to take on minimal opportunities to direct films himself. At first they were designed to bring in cash for the Swedish Film Institute, which had been in a state of decline for years. After his first ventures were often failures at the box office, he would have been fired if Sjöström had not intervened on his behalf. When *Smiles of a Summer Night*

won the Cannes award in 1956 and became a world-wide success, Bergman was given a more or less free hand to write and direct whatever he wanted. The first great period of his art issued from this social setting as well as the events in his personal life that have always penetrated the fabric of his movies.

As someone who blatantly put his own experience into the films he made, which he could readily do because he wrote their screenplays, Bergman is preeminent and almost solitary among great filmmakers. Welles also wrote the texts of his own movies, but under very different circumstances. After the turmoil that accompanied *Citizen Kane* and the disastrous reception of *The Magnificent Ambersons*, which the studio had truncated, Welles spent the rest of his life scrounging for money he needed to make his movies, often having to provide it himself. Bergman was virtually unique in other ways, mainly of his own choosing. He exploited cinematically his life as a thinker, as the offspring of an emotionally dysfunctional marriage, as a man who, during his early adulthood, loved several women (five of whom he married and from four of whom he was divorced under conditions that were frequently painful to him), and as an artist who felt and expressed the oppressiveness of contemporary civilization.

Bergman has spoken on many occasions about these personal foundations of his work, and he wrote about them in two autobiographies—*The Magic Lantern* and *Images: My Life in Film*. The title of the former refers to a toylike projection machine that he was given as a young boy and that wholly captivated his childish imagination. It enters into Bergman's film *Prison* together with an original and highly farcical movie-within-the-movie that is projected by the machine.

The overall title of the second book is intriguing because of the ambiguity in its subtitle. We would normally read it as an account of the filmmaker's life as it occurred in the actual creation of his films—his experiences on and off the set with actors, producers, and other professionals, together with the many problems inherent in the making of each movie. That is the total meaning of the title of Renoir's book, also called *My Life in Film*. But in the case of Bergman, it is suitable, I believe, to read his subtitle as indicating the presence, and aesthetic relevance, of his own life within the very structure of his films, and as being a directly causal factor for the contents they contain.

Watching most of Bergman's movies, we get a glimpse of something or other that the filmmaker has once experienced and then retained, lodged within his

imagination, for decades in some instances, until it finds
its fictional outlet. At the same time, this bit of Berg-
man's life is never used as a duplication of whatever
may have occurred in the past. Even the films that can
be deemed clearly autobiographical, since they rely
upon representations of his relatives or immediate fam-
ily, are transformed by the pictorial make-believe that
renders the images independently engrossing as we
follow them. If we were completely ignorant of their
partial and imperfect relation to people and events in
the life of the Bergman clan, their impact would be
more or less unaffected.

I don't wish to deny that we all have a voyeuristic
and sentimental, in the sense of gossipy, curiosity about
the private experience of artists and their associates or
kinfolk. Bergman puts so much of himself into his films
that one can assume that he is intentionally capitalizing
on our prying inclinations of that sort, as well as expos-
ing facts about his life and his origins as a patient might
do with his psychiatrist. But over and above this com-
mon though unduly emphasized potentiality of all art,
of all human communication perhaps, Bergman's films
are outstanding because they succeed in directing our
attention to ideas and problematic feelings that both his
narratives and the images that manifest them portray as
the reality of what human nature is.

Movies like *The Best Intentions*, *Sunday's Children*, *Private Confessions*, *Fanny and Alexander*, *In the Presence of a Clown*, and even *Faithless* (in which there is an author whose name is Bergman) are overtly self-referential in dealing with the filmmaker's lineage and historical being. But more important, they are all investigations into the kind of person that he himself was and is. In that respect, they are part of an enormous mosaic that demonstrates the world of Ingmar Bergman. As such, his life work is an enterprise parallel in scope to Balzac's *La Comédie Humaine*, though lacking its sociological amplitude and concentrating more upon the creator's circumstance as an artist born in the early twentieth century.

Renoir said that he felt as if he had made only one film in his whole life. Bergman could have said the same, but he is unlike Renoir in having made his one movie about himself. Being what he described as "very neurotic," he presents the male characters in most of his films as troubled, usually weak, dependent upon the emotional support of women they wish to love but somehow cannot, not always artists but generally detached from the kind of occupational fulfillment that most men have coveted in their social and political pursuits, failures or at least handicapped as husbands and fathers.

Bergman's two most famous films, *The Seventh Seal* and *Wild Strawberries*, are about men who struggle against a sense of worthlessness, obvious in one but hidden in the other. In *The Seventh Seal* the Knight returns home demoralized after having fought in the Crusades. He travels to the castle in which his wife, whom he abandoned ten years earlier in order to go to war, is still living. He hopes that she will take him back and help him recuperate. She does, but when Death comes to claim the Knight, he takes her as well. Throughout *Wild Strawberries*, the old doctor tries to overcome his latent fear of being inadequate as both a human being and as a practicing physician. After the end of a cathartic day of travel to receive an honorary degree, his self-esteem is finally restored by a vision of his mother and father, as he remembers them from childhood, acknowledging his existence.

There is great variety in the playing out of Bergman's themes, and in his final period we find a tentative solution to the problems that they pose. Some motifs are moreover constant in his films. From the very start they show vast sympathy toward women who must live with the damaged or unstable men whom they care about for one reason or another. Bergman is unequaled in his perceptive understanding of how his female protagonists suffer in our society despite the strength of

intellect and compassionate feeling that many of them have. This is evident in films as diverse as *Cries and Whispers* or *The Silence*, on the one hand, and *The Touch* or *Private Confessions*, on the other. For their part the males seem to be forever contemplating suicide, and in love relations seeking a strong woman who can nurse them back to health.

Even when they assume the role of an aggressive or beguiling male, the men crave a motherly female who will sustain their infantile needs. Over and again Bergman reverts to the image of men being held like babes in the arms of the women who can tolerate them, sometimes even in the Pietà position. Don Juan, the protagonist in *The Devil's Eye*, manages to seduce the young bride-to-be whom he has targeted for his list of conquests only because she feels a maternal instinct of protectiveness toward him. In the subplot his servant succeeds with her mother for the same reason.

In *Sunday's Children* the character who represents Ingmar at the age of eight watches with great interest a servant breast-feeding her baby and then remarks that he wants to take its place. The older children ridicule him, but the servant merely says that his mother would not approve. This motif permeates the phenomenology of the fragile or impaired males in Bergman's movies.

Writing about himself as an artist, Bergman says
that people who point out the extent to which his nar-
ratives hark back to his childhood experiences are
mistaken in one respect. It is not merely a question of
his remembering what happened at that time—in
recalling, in *Fanny and Alexander*, for instance, exactly
what his grandmother's rooms looked like when he
was young—but rather that he has continuously lived
with those images as if to him they were still current
realities. He cogently insists that this has been a major
resource in his creativity.

Acknowledging the supreme and all-important
presence of Sjöström as the main character in *Wild
Strawberries*, Bergman asserts that the movie really
belonged to this man whose greatness affected him so
much. But though Bergman is surely right in what he
says, the fact remains that the attempt to reexamine
earlier experiences is entirely geared to his own child-
hood and not Sjöström's or anyone else's. Bergman tells
us that he had the same dreams himself, and that the
summer locations and family events they revisit are
only slightly modified copies of what had been lodged
within his sensorium throughout the years. Even the
portrayal of the guilt-ridden sexual infidelity of the doc-
tor's wife is a duplication of the failure in his mother's
unhappy marriage to his father. Having been asked

why all his films persistently focus on the human face, Bergman replied that he is always looking for the face of his mother. After she died, he collected photographs of her in a little documentary that he called *Karin's Face*. In *Saraband* a photo of the face of Anna, the dead and highly idealized mother who understands what love is better than any of the other characters, recurrently appears as a touchstone of how to live.

Bergman's ambivalent relation to his father when he was young pervades not only the autobiographical *Sunday's Children* but also the fundamental themes in *The Seventh Seal*, *Through a Glass Darkly*, *Winter Light*, and *The Silence*. These are all generated by Bergman's attempt to liberate himself from the strictly orthodox Lutheran faith that his father inculcated in his progeny, and that instilled in the young Ingmar a sense of self-denial and a devastating fear of death.

Critics often speak of what they designate as a "Bergman film." They are alluding, rightly, to the major themes he progressively develops and to his special way of presenting them cinematographically. But one must also remember that Bergman's *manner* of presentation included different realistic effects together with others that used the camera nonrealistically and with great originality as a creative instrument in itself. His productivity ranges from his early movies that show

the influence of film noir or directors like Marcel Carné
and the Italian neorealists to those that we recognize as
entirely Bergmanesque, from black-and-white dramas
and comedies to films in brilliant and often high dra-
matic coloration, from works for the big screen of a
moviehouse to others made for television and even dig-
italized, from large-scale films to more intimate ones
with only a few characters, from stories told in a linear
continuity or with flashbacks to his final masterpieces
that consist of a series of separate events or dialogues
("conversations" he occasionally calls them), as in *Scenes
from a Marriage*, *From the Life of the Marionettes*, *Private
Confessions*, and *Saraband*.

In this innovative fluidity and openness to change
as time goes by, Bergman's creativity resembles the
inventiveness of Picasso or, more particularly, Monet.
Picasso went through many stages, some of them paro-
distic of what other great artists had achieved. Monet
generally remained himself, but his techniques altered
as he got older and vied with the proponents of more
current styles that he could admire and from which he
always felt he might discover new possibilities for his
own art.

Perhaps it was as a means of preserving and assert-
ing his identity that Bergman employs repeated tropes
that tend to link the successive movies. For instance, in

quite a few of his films his protagonists have the same first names, and sometimes identical second names although they are not otherwise related or alike. Karin, his mother's first name, is especially prominent, together with Anna, Marianne, Ingrid, Maria, Märta, Alma, Sara, Johan, and Henrik. Egerman as a second name recurs without any suggestion of a family tie, and Åkerblom, his mother's maiden name, appears without always being autobiographical.

In a similar vein, Bergman systematically uses scenes of people sitting around a large dinner table as a mise-en-scène for some new direction to the plot, in a couple of films through a magic love potion that is consumed on that occasion. Also the presence of, or reference to, wild strawberries occurs not only in the movie that has that title but also in *Summer Interlude*, *The Seventh Seal*, *Through a Glass Darkly*, *Fanny and Alexander*, *Sunday's Children*, and *Private Confessions*. The strawberries are not a symbol of something but rather reminders of a natural goodness in life that Swedes have widely cherished. They are sanctified in *The Seventh Seal* when Mia holds out a bowl of strawberries for everyone to share. They were doubtless a fruit that Bergman enjoyed as a boy and that evoked in him happy memories thereafter. So powerful were the reminiscences of his childhood that Bergman inserts

into the beginning of *Saraband* a nostalgic shot of Johan's house on an isolated cliff in the country. What we see is actually a photograph of his grandparents' country home, where Bergman used to spend his summer vacations. In the course of that film he presents an exchange between a father and his son that replicates what he and a child of his own said to each other many years before: "He once related that he acknowledged to one of his sons, then a teenager, that he might have been a bad father, and the lad spat out, 'Bad father? You've never been a father at all.' The dialogue is repeated verbatim in *Saraband*."[3]

These unifying quirks serve as signatures to Bergman's personal view of our reality. The phenomenon is evident in the title he gave to his version of Mozart's *The Magic Flute*. It is announced as *Ingmar Bergman's The Magic Flute*. One cannot assume that his name was affixed to the title because he was by then a famous filmmaker, as with Alfred Hitchcock and many others, since this is the only production that names a Bergman movie that way. I take the longer wording as an admission that Bergman's offering is an adaptation that alters—on occasion greatly, as I point out in my text—the narrative that Mozart and Schikaneder had created.

Like most theater directors, Bergman usually made cuts and reinterpretations of the plays he was presenting. In the case of August Strindberg's *Miss Julie*, he chose a tall and imposing woman for the leading role and instructed her to act with maximum forcefulness instead of depicting Julie as a weak woman who succumbs to the dominance of her male lover.[4] The latter interpretation had been what everyone before understood as faithful to Strindberg's intention. In the case of *The Magic Flute* Bergman went even further. As we will see, he changed the script to suit his personal conception.

Most artists are not able to imbue their productions with their own identity as fully as Bergman did in film after film. For architects, sculptors, painters, or musicians the subject and the continuity of their work are rarely portrayals of themselves, even indirectly. Poets and writers of novels or plays have always had greater freedom in that respect, and some filmmakers have successfully emulated them. Federico Fellini is a good example of that. But few others could do so to the extent that Bergman did.

Having begun his professional life as an editor of other people's scripts, he went on to write almost all the screenplays for his more than fifty films. These

screenplays were generally novelettes or literary drafts that included none of the cinematographic details that appear in an ordinary movie script. Bergman directed with no prior decisions of that sort except for the verbal agreement that he and the cameraman—Gunnar Fischer or Sven Nykvist, most notably—had reached after lengthy deliberations. That gave him and the actors the ability to go beyond any initial storybook instead of closely adhering to it, which directors like Hitchcock demanded. As I will try to demonstrate, Bergman used this opportunity to treat the camera as itself a means of telling the story, while also being the vehicle for transmitting an extensive system of ideas.

In the process of shooting and then editing films, Bergman was no longer a writer, of course. But since he was the source of whatever text he had written, or adapted, he could avail himself of the idiosyncratic and self-expressive nuances that authors regularly have access to. From this point of view, one can see Bergman's artistic venture as similar to that of a poet like Walt Whitman. Working within a visual medium, Bergman did not overtly proclaim, as Whitman had, that he sings of himself in everything he says or does.[5] Nevertheless his doing so was comparable. Bergman resembled Strindberg, and other playwrights, in proffering different aspects of the author's own intimate experience

through a dramatic vehicle that reached at will beyond any limits of factuality. Being a man of the theater, Bergman learned—better than any other moviemaker, I believe—how to employ devices native to the stage as an integral mechanism for some of his most successful films. I am thinking in particular of the ones he made as television plays consisting of the dialogues between two or three characters whose presence dominates the screen as they would on the stage of a theater. Even accomplished literary filmmakers like Welles and Renoir do not approximate Bergman's achievement in this genre. He virtually created a new art form that merged in this fashion the theatrical and the cinematic.

In several interviews, Bergman spoke of himself as a craftsman, a maker of objects that people could use to satisfy some daily need. Like any carpenter or other workman, he denied that his productions were designed for eternity or some idealistic goal related to art-for-art's-sake. If his efforts are not of interest to anyone, he said, they can and should be discarded, totally ignored by prospective audiences. Authentic as this disclaimer may be, Bergman's work transcends any arbitrary separation between art and craft. This may apply as well to many products of carpentry or other handiwork, but the deliberate and delving thoughtfulness in Bergman movies gives them a further dimension

that only the greatest creativity attains. And in his case, as I have been suggesting, it partly results from the fact that his temporal being so completely and so obviously permeates his endeavors as a filmmaker.

While seeing Bergman as one who, through images and their unification, sings of himself in the manner of Whitman, one can also perceive him as a visual composer inspired by the aesthetics of music, which he called "absolutely necessary" in his life.[6] As a cinematic musician he structured imagistic effects in a rhythm and dramatic harmony comparable to the sonic abstractions of a Bach or a Mozart. At the same time his art was wholly representational. Its meaningfulness and applicability to human experience had to emerge from the progression of an explicit narrative. Even so, Bergman differs from Hitchcock in telling the story not as a captivating figment of the imagination or as the instigator of emotional responses of fear or suspense, but rather as the basis for cognitive explorations that the filmmaker was pursuing. Without doubting that there is in Hitchcock a philosophical element of his own, we can recognize Bergman's deviation from him as a matter of priorities.

Those who are interested in surface entertainment usually prefer Hitchcock's approach to filmmaking. Bergman's may seem to them heavy-handed, boring,

often depressive, and entirely too difficult for a visual medium aimed at large numbers of people. Hitchcock's artfulness works for his more commercial orientation, but Bergman's methodology succeeds because of the daring techniques (more daring than in Hitchcock, and correspondingly more insightful) that continually astound his kind of audience.

Hitchcock was masterful in his way because he included much more than suspense in the texture of his movies. He regularly mingled romance, humor, exciting action, an infectious search for something, and clever shots designed to startle us. Even in Bergman's melodramas, some of which are also thrillers, none of this is prominent. Apart from the larger breadth of his thinking, Bergman compensates for any lack of Hitchcockean public appeal through his increased employment of violence, nudity, and overt sexuality.

In Hitchcock these are greatly curtailed, carefully tailored to social mores and moviegoing tastes of the period. Hitchcock points out that the week's shooting and innumerable takes of Janet Leigh and her stand-in never show on-screen any bit of their erogenous zones, even though the character is naked in the shower when she is violently assaulted. By the time Bergman was making his major films, total nudity, violence, and blood in vivid redness were capable of being displayed,

since governmental censorship and audience attitudes toward graphic sex had changed.

When Hitchcock made *Frenzy* toward the end of his career, he could avail himself of this greater latitude; but his last film, *The Short Night*, was considered so extreme in its nudity and violence that the studio refused to produce it. While Bergman's use of sexual effects is scarcely pornographic, the films he made, especially from the 1960s on, sometimes contained language and imagery that Hitchcock could not have used. Hitchcock would nevertheless have approved of their realism and their shock value at that point in the story.

We may ask whether this kind of recent freedom makes movies better. When I was younger, I thought that it did not, and I still find myself repelled by images of violence or contrived sexual performance. I have always enjoyed the sight of naked female bodies if they are handsome. That is an aesthetic criterion, and nowadays I am convinced that a related one can possibly justify the violence or overt sexuality that a sensitive filmmaker employs in his art. The beautiful cleanses and purifies even that which revolts and disgusts us in itself. If the images conduce to an increased likelihood of violence among those who are influenced by them— the susceptible younger ones, for instance—we may feel

that dissemination of such incentives must be controlled on purely moral grounds. But that scruple is applicable to every element in our daily existence, whatever its contents may be.

Of prime importance in this matter is the level of artistic value and the fact that the action or event is perceived as fictional, though possibly true to life. The Greek tragedies pass this test, as do the plays of Shakespeare, in addition to many other works that have been condemned as offensive or lewd. The violence in them or their sexual crudity may be unpleasant to watch, but as operative components in a work of art they have a viability that gives them aesthetic and justifiable sanction. Ester's sickly masturbation in Bergman's *The Silence* and the self-inflicted, bloody mutilation of Karin's genitals in *Cries and Whispers* are not erotically arousing, or even enjoyable to hardly anyone, I assume, but they need not be experienced as morally horrifying or unacceptable, since they have a valid function within those films and do no harm to potential viewers.

In this connection, I remember a cartoon showing two old biddies in Elizabethan England passing a large placard that proclaimed "Now showing, tonight and tomorrow, *Macbeth, Othello, Hamlet*." One of the women says to the other: "Same old thing! Sex and violence, sex and violence!" We laugh at this because we feel

that these possible patrons are deficient in the aware-
ness and appropriate distancing required to appreciate
works of art. They are like Cervantes' Don Quijote
when he pulls out his sword and attacks the abusive
Moor in a puppet show he is watching.

At a performance of *King Lear* many years ago, W. V.
Quine quietly muttered to me just before the gouging
of Gloucester's eyes: "This part's hard to take." I under-
stood the sympathetic feeling he was expressing, but I
experienced nothing comparable myself. For me it was
all marvelous make-believe, and less upsetting than a
wholly realistic representation in a movie might be. I
eventually came to realize that even then, in the hands
of a superlative filmmaker like Bergman (or Hitchcock),
the technical artistry of the presentation reconstitutes
and transmutes any ethical or humane responses that
would normally be relevant.

Though Bergman is often very harsh in his criticism
of earlier films he made, he constantly defends his
frequent showing of sex and violence in them. On the
other hand, he apologized for examples of intellectual
dishonesty that became apparent to him in later years.
He lamented "the spiritual jiggery-pokery" in *The Vir-
gin Spring*, despite its having been awarded an Oscar
and attained commercial as well as critical success. That
movie included, he said, "a totally unanalyzed idea of

God. The mixture of the real active depiction of violence, which has a certain artistic potency, with all this other shady stuff—today I find it all dreadfully triste."[7] And though the virtues of *Through a Glass Darkly* were widely appreciated and it too won awards when it first appeared, Bergman detected a "gross unveracity" in it since even at the time it was made he himself could not tolerate the religiosity of its underlying message: "*Through a Glass Darkly* was a desperate attempt to present a simple philosophy: God is love and love is God. A person surrounded by love is also surrounded by God.... So here we started with a falsehood [on the part of the filmmaker], largely unconscious, but a falsehood nevertheless. In a weird way, the film floats a couple of inches above the ground. But falsehood is one thing, the weaving of illusions another."[8]

In relation to *Through a Glass Darkly*, I think Bergman's sense of unease may be defensible, but for reasons other than his. The religious statement he cites occurs at the end as a terminal sugaring of the pill. Like the boy's sudden reconciliation with his father, it comes through as a glib and conventional gimmick concocted to prevent the audience from being totally dismayed by the agony they have seen. The narrative in *The Virgin Spring* is, however, basically different. The miracle presumably caused by the unanalyzed God in whom

Bergman did not believe is fundamental in the movie as a whole. Everything in it has led up to it, and its inclusion is entirely explicable by the fact that what we have been watching is the unfolding of a medieval legend. Bergman's disdain for his film is puzzling to me, since it contravenes his acute understanding of how artistic imagination is able to create a nonliteral order of truthfulness. The strain of magic in his work relies on that. How then can he deem it dishonest for a story to invoke some mystical or unreal element as required? And didn't Bergman's love of Bach's music reach beyond the orthodox faith without which Bach would not have written his compositions?

In the case of both these films, Bergman's evaluation is possibly geared to his own situation as a kind of demiurge, not unlike the one in Judeo-Christianity, who constructs beings in his own image and as a reflection of his own thoughts and individual experiences. As I have suggested, Bergman's doing this throughout his films constitutes the source of his achievement as an artist. It is only his critical judgments, like a father who wants his children to be perfect copies of himself, that strike me as distortions in these instances.

Other aspects of Bergman's overall view of art are likewise problematic. In 1965 he gave a downbeat account of his creative life in an essay entitled "The Snakeskin." Characterizing what he and fellow artists

do in our society, he invokes the image of a dead snake whose skin remains intact but whose inner flesh has been gouged out by voracious ants. When they march on the inside, the skin looks to casual observers as if the snake is still alive and moving forward on its own. The bustling ants, himself and the other artists, are driven by an endless curiosity that replaces the hunger for contact and fellowship with other creatures that was their initial motivation.

Bergman recognizes the limitations in this self-centered state of affairs, but he ends his confessional by adducing an "enormous advantage" that the artist gets: he "shares his condition with every other living being who also exists solely for his own sake. When all is said and done, we doubtless constitute a fairly large brotherhood, which thus exists within a selfish community on our warm and dirty earth, beneath a cold and empty sky."[9]

In more recent stages of his development, Bergman amplifies this partial view. Six years after the preceding statement he reveals how vastly the need for human contact both pervades and bolsters his work. He goes on making films, he tells an interviewer, because

it's an outgrowth of an enormous need for contact. I have an enormous need to influence other people, to touch other people both physically and mentally, to communicate with

them. Movies, of course, are fantastic media with which to
touch other human beings, to reach them, to either annoy
them or to make them happy, to make them sad or to get
them to think. To get them started emotionally.... There is
also something about the work itself that you get very depen-
dent upon. You are part of a group. If you are a relatively
inhibited, shy and timid person like me who has difficulty
establishing deeper relations, it is wonderful to live in the
collective world of film-making.... Through making films
and staging plays you constantly come into contact with
other people—one intrudes into the problems of others.[10]

Making contact with other people remains through-
out Bergman's approach as the permanent residue of
his speculations about ethics and religion. As I will try
to show in the chapters that follow, it is a narrative
theme that propels all his films as well as the experi-
ences that are reflected in them. In studying his work
from this point of view, I draw upon the positions I
took in previous books that explore the interrelation-
ship between cinematic meaning and technique as well
as the role of philosophical thinking in the use of both.
In some respects this methodology is more definitely
appropriate to Bergman's work than to that of most
other filmmakers. Even so, the details and the ramifi-
cations of his creative life are highly diverse. I will be
focusing on them.

1

Magic, Myth, and the Return to Childhood

I begin by suggesting a kinship between Ingmar Bergman and both Preston Sturges and Orson Welles. The special relationship between the latter two seems evident to me. Their first, and most famous, masterworks were tours de force that appeared in 1941, the year America entered World War II. Though all of Bergman's films belong to a postwar generation, he resembles these filmmakers in many respects. Starting with his comedic output, we can't help but see how his *Smiles of a Summer Night* (1955) includes elements, farcical but serious, that were also developed in Sturges's *The Lady Eve*. Egerman falls into a puddle outside Desirée's apartment house as part of his education in the nature of love, just as Charles does in the Sturges movie when he gets off the train on his matrimonial night and lands in the mud.

Both Charles and Egerman the lawyer are smug
bourgeois types who think they know what love is but
have to be retrained by an astute woman whose imagi-
nation and knowledge of life are much less superficial
than theirs. Though Egerman has had mistresses in the
past and is married to a young girl he adores in a
fatherly way, he has never *fallen* in love. He needs to be
tutored by Desirée. By the end he has learned a lesson
or two, though it remains unclear whether he can attain
an authentic experience in this aspect of life. Desirée is a
famous actress whose success on stage is matched by
her ability to be a good mother as well. Though Stur-
ges's Jean/Eve does not perform in the theater, she has
the requisite talent. It is manifested at first in her being
an artful con woman at cards and then a phony but
wholly convincing mimic of English nobility. Eve has
no children yet, but her desire to be everything Charles
wants her to be foretells her eventual role as mother.

Charles differs from Egerman in advancing further
toward an ability to love. Once Jean/Eve forgives him
for having deserted her, and he forgives her for her
behavior as both Jean and Eve, they are able to march
off into the world outside Eden hand in hand, as in
Haydn's *The Creation*. Though we cannot be sure that
Egerman and Desirée will reach that mythic resolution,
they are reunited at the end. Moreover, Desirée's boy,

possibly Egerman's child and bearing the same first name, reinstates his paternal manliness in partial compensation for the loss of his grown son, who has now run off with the father's virginal bride.[1]

The tie between Bergman and Welles consists of interwoven strands that I will describe later in this book. Most fundamental, I think, is their belief that magic is the basis of filmmaking. In the case of Welles, who was himself a trained magician good enough to perform onstage whenever he was given the opportunity, we are rarely shown characters in his movies who engage in acts of magic. *F for Fake* is the only one of his films that delights us with them. Even so, the concept of the magical underlies everything that Welles does in his cinematic efforts, which nevertheless strive for a realism that can be true to ordinary life. Bergman shares this joint aspiration, but he carries it further than Welles. How he does so, through mythological motifs and through explorations that go beyond them, will launch us directly into the creativity of his philosophical perspective.

Despite their differences, Bergman resembles Welles in denying that symbolization plays a significant part in what each of these two provides as a filmmaker.

"There are no symbols in my pictures," Bergman said in an interview. "What I hate most of all in art is the self-conscious symbol, the symbol that is put here like a strawberry on the ice cream. I think that's terrible, terrible!"[2]

As an example, take the famous sequence at the beginning of *Wild Strawberries* in which Isak Borg depicts a frightening dream he has had. We see him as an old man walking through deserted streets in an unidentifiable city; a horse-drawn hearse without a driver appears out of nowhere, and when it strikes a lamppost, a wheel falls off; an open coffin slides into the street near Borg; in the coffin he sees a body with his own face; as he draws close to the corpse, its hand grabs his, either to pull him in or to have him pull it out; he then awakens with a start. One could take this as a pictorial representation of symbols relevant to the death Borg knows he must undergo before long in view of his advanced age but that he is determined to resist as best he can. While all that belongs to the narrative in this film, Bergman repudiates the idea that any such symbolization can truly explain the nature of his work. If the claim he makes is true, as I also think, how should it be understood?

This sequence, like the other dreams inserted into later parts of *Wild Strawberries*, is meaningful only in

the context of the aesthetics of film itself. As a product of either photography or animation, together with special effects that mimic photography just as magic mimics everyday causality, cinema is inherently a visual, literary, and sonic art designed to present realistic appearances that resemble what we ourselves encounter in normal consciousness. A dream is not like that, and neither is a daydream. Both are idiosyncratic art forms of their own that film exceeds and outdoes to the extent that wakefulness encompasses much more than dormant or diminished alertness does.

Instead of being limited to the mere assertion of symbolic ideas or vistas, film enriches them in meanings and techniques that develop throughout a narrative and are thereby capable of making it true to life as a temporal phenomenon in a conscious audience and in the dreamer alike. The notion that dreams in a movie contain dazzling symbols that we experience while asleep falsifies the uniqueness of a cinematic production. While we know that a scene like the one I have just mentioned is a *rendition* of something that a person might dream, we simultaneously recognize that "it's only a movie," as Hitchcock kept saying. Cathartic as they can be, and powerful as their effect upon our emotions may remain for a long time, the images must operate within the film through an

immediacy that is similar to, though not the same as, the way we perceive the world in our waking confrontations with it.

This means that when symbols are present in a film they function as imaginative devices beyond themselves as *merely* symbols. They exist as structural units within an ongoing continuity in the plot. It is more than just a question of "willed suspension of disbelief," the term that Coleridge employed to characterize the aesthetic dimensions of fiction as a whole. Instead, what happens is an appropriation of something we see or hear as integral to the rest of the artistic product and its referential content, which differs from work to work. We bestow a special kind of meaning upon the symbols as well as the dreams in which they occur. We treat the symbols not as nuggets of cognitive import or, in Bergman's apt metaphor, as strawberrries on top of the ice cream, but rather as inventive contrivances that further a quasi-realistic story while also reminding us that the totality is only make-believe. The magic in feature films, and to some extent in filmmaking of every sort, resides in this creative power. In addition, as I will argue throughout, it is the magical effect of flickering images on a screen or monitor which makes film not only inherently mythical in itself but also a conveyor of significant myths that have mattered greatly to many people.

The fundamental mythology of *Wild Strawberries*, as in several of Bergman's films, is vividly incorporated in the ambiguity within Borg's initial dream. We cannot know whether the hand that rises from the coffin is trying to drag him into it or trying to become free of its own enclosure there. The face and the hand that Borg sees are his own, not mirror images of him but rather parts of himself. The meaning in this magic, and in Borg's revulsion from it that causes him to wake up, is the simultaneous existence, as in everyone, of forces that drag us to our death as well as those that we fight against by asserting our instinctive desire to go on living. Being the metaphysician that he was in writing *Beyond the Pleasure Principle* as he did, Freud states that this bivalence suggests a conflict between a wish for death and a love of life, both of them programmed ineluctably in every organism.

That is a mythological account that we need not espouse in order to explain either the dream or the narrative use of it that Bergman subsequently develops in *Wild Strawberries*. What can be said, however, is that every scene of this movie is constructed around the relation between life and death, and that we cannot wholly separate them or decide at any single moment which is dominant. The resulting ambiguity operates as a dramatic theme, raising recurrent doubts about the

possibility of any benign harmonization between the
two phenomena.

In the final shot of Borg as he falls asleep after his
trying day, a slight smile lingers on his face as if in cul-
mination of the satisfying though difficult experience he
has had. In the role of Borg, Bergman cast his mentor,
Victor Sjöström, then age seventy-eight and formerly
the greatest Swedish director-producer-actor of his
time. The terminating close-up of his face reveals the
wisdom and fortitude, but also the fragility, of the man
Bergman revered. It is a visage that manifests all the
contradictory truths that a person like him might have
gleaned through many years in his profession. Through
aspects of his personality and in his face alone, life
shows forth its colors as a prolonged struggle with
death. At the end of *The Seventh Seal*, in which Death
finally sweeps all before it, Bergman also leaves us with
a glimmer of hopefulness. The likable and loving fam-
ily of actors survives for the time being. Other Bergman
films portray in variable ways both the ambiguity and
the conceivable harmonization between the two coordi-
nates of our being.

We can appreciate the nature of Bergman's mythic
approach by comparing his type of filmmaking to the

novelettes he wrote for the actors to use instead of scripts. They often differ vastly from what eventually appears on the screen. In one sequence of *Wild Strawberries*, Borg returns in a dream to the summer house that he and his family lived in during periods of his childhood and early youth. Bergman's text reads very much as it would in a short story or stage play. In the voice of the self-referential narrator he describes, as follows, the dreamer's experience in the dream while also commenting about what is occurring at that time: "I understood then that one cannot easily converse with one's memories. This discovery did not make me particularly sad. I decided to keep quiet and hoped that this unusual and pleasant situation would last as long as possible."[3]

In the film itself we see Borg on the peripheries of what he observes and hears. He is an unseen audience, as are we in the theater in relation to what is being shown before us. In another scene, Borg the dreamer enters into the current dream inasmuch as he converses with his then girlfriend (Sara). She is still a young person, whom we and Borg have seen in an earlier dream of his, but he remains throughout the old man who has been telling the story from the start. To underline the difference between them, the Sara-memory forces Borg to look at himself in a mirror. Given what he sees, she

points out: "You are a worried old man who will die
soon, but I have my whole life before me."[4]

I cite these two scenes because, in reading them, we
have little sense of their magicality. On the page they
only constitute descriptions of different kinds of dreams
that all of us have doubtless had. Whether or not the
dreamer realizes that what he or she perceives is just a
fantasy, the contents flow by as in waking life and may
even be tinged with comparable feelings. But when the
scenes are enacted in a movie, with the enlarged and
greatly detailed precision of cinematic imagery right
there before us, we are seduced into compliance with
the persuasive potency of their irreality. Bergman re-
sorts to this effect in almost every film, regardless of
what he wishes to express through one or another
dream that his characters have. Nor is the cinematic
magic in the second scene more notable or jarring than
in the first. In the real world we cannot converse with
persons as they were in the past, but neither can we
stand by at the edges of their prior being and spy upon
them as they once existed.

Awareness when we are awake is radically unlike
whatever awareness we may have when we are asleep.
The magicality of movies results from its melding the
two states. We are then passively receptive as in a
dream and yet fully cognizant of the fact that the flick-

ering images are in themselves as real as the elongated
screen on which they appear, or even the living, breath-
ing actors who originally stood before the motion
picture camera that photographed them. Furthermore,
the magical effects in Bergman films are by no means
limited to the contents of dreams. In *Wild Strawberries*
they occur as ingredients in the quasi-realistic account
of Borg's momentous day. In exceeding any ordinary
reality, they demonstrate how introspection and pro-
gressive transformation arise in him on that fictive
occasion.

In movies like Buster Keaton's *Sherlock Jr.* and more
recently Woody Allen's *The Purple Rose of Cairo*, the
dreamlike character of the cinematic art form becomes
a part of the narrative itself. The plot then involves—in
fact, depends upon—the ability of a spectator to enter
literally into the dreamworld being presented on the
screen in addition to the imagined capacity of a fictional
character to enter conversely into the world of the spec-
tator. In *Wild Strawberries* Bergman alters this motif by
having the dreamer who has been watching his own
dream both interact with it and then introduce what he
has been observing into his waking life thereafter. In its
entirety, *Wild Strawberries* is thus a highly integrated

quest, Borg's dreams and his conscious experience jointly contributing to the finding of truths about himself that have been obscured by his routinely "pedantic" existence, as he calls it. The film is from beginning to end an exploration into the meaning of his life thus far.

As such, the narrative and its diverse techniques enact a search in the manner of a Hitchcock thriller. Fleeing the corpse in his dream, Borg is trying to evade unknowable forces that not only want to bring about his death, as in Hitchcock, but also consider him worthy of this punishment. In addition to being an escape from submission to his own mortality, Borg's trip to Lund is also a reaching out for anything that can reunite him to the profundities of his life, and of human existence in general. Since Hitchcock rarely ventures into inquiries of this type, he generally avoids the persistent probing that Bergman undertakes.

Bergman's use of dreams also resembles but exceeds what Welles aspired to in *The Trial*. Welles characterized the whole of that movie as a kind of dream, a nightmare. But he also insisted that he was not reproducing the contents of any literal nightmare but rather was conveying the *feeling* that people experience when they have one. In the case of Borg, his presented dreams express the feelings of deficiency, failure, and possible criminality that he must eradicate as best he can if he

wishes to stay alive emotionally as well as physically. These aspects of his life are not inserted as photocopies of some reality. They are cinematic devices that further the investigation in which Bergman is creatively engaged.

There are also components of the professor's dreams that upset him without his, or our, knowing exactly why. For instance, in the first dream the camera lights upon a large clock without any hands. Borg frowns as he looks at it; he is uncertain what to make of it. We in the audience may interpret the defective clock to mean that the telling of time is no longer possible for him because he has no future left. But much later in the story, when he and his daughter-in-law Marianne visit his elderly mother, we learn its true significance. The old woman asks Borg to give his son Evald the pocket watch that belonged to his grandfather, her deceased husband. Borg is amazed by the fact that it too has no hands. As he stares at it, we realize that the watch, like the clock in his dream, locates him as the son of a dead father, which he will shortly be in relation to Evald, whom he is due to see that day.

The nature of Borg's relationship to his son will become clear to him in the course of his trip. Like Marianne, who is separated from Evald, the old man has been cut off from intimate contact with him.

Marianne harps upon Borg's coldness and refusal to help them with their marital problems. She claims that this is the cause of his alienation from Evald as well as from herself. She goes as far as to say that Evald hates him as a result. We see on Borg's face how wounded he feels by the possibility that this may be true.

After she and Borg have stopped off to see Evald's grandmother, who is ninety-six years old, Marianne makes generalizations about the "cold womb" that has brought forth the frigidity in both Borg and his son. Being a medical doctor, Borg tells his mother that the bodily coldness she feels is brought about by her low blood pressure. But Marianne insists that the whole family, including Evald's mother, are emotionally cold. By the time the car reaches their destination, however, she and Borg have made progress in their relationship to each other. They cordially discuss her decision not to abort the child she is carrying despite Evald's refusal to allow it into the world. At the end Marianne and Borg feel warmly toward each other, and she and Evald take major steps toward reconciliation.

The people Borg and Marianne pick up on the road to Lund figure greatly in his search for meaning. Foremost is the young girl Sara whom he meets by chance near the house in which he and his family spent their summers. His dream about that location is disquieting

to him because it reveals how inadequate he was as a suitor for the affections of his cousin Sara. The two Saras are played by Bibi Andersson, and they are alike in being girls who vacillate between two boys who court them in different ways. Cousin Sara in the dream is vaguely engaged to Isak (himself) but she finds him bookish and sexually backward, while Sigfrid, his older and more aggressive brother, seems better able to satisfy her needs. Sigfrid is the one she marries, and in a later dream Borg observes how happy they (and their baby) are, compared to him, who remains a lonely outsider to what he too wanted. His relationship with the real Sara in the car is quite different. She likes him as a kindly grandfather type with whom she can easily discuss her feelings toward the two young fellows who are accompanying her on their trip to Italy. After the honorific ceremony at Lund, she tells Borg that he is the one she really loves. He is under no illusions about the meaning of her words, but hearing them has a gratifying effect.

The experience with the bickering husband and wife, Mr. and Mrs. Alman, whom Borg picks up after their car crashes during a marital fight, also has personal importance for him. Like many of the couples in Bergman films, this one is engaged in a sadomasochistic symbiosis that Strindberg had endlessly elaborated in

his plays, several of which Bergman directed onstage and most of which he much admired. But Bergman also reconsiders all that. As in the syllables of their names, where Strindberg ends Bergman begins. As I will try to show in the course of this book, Bergman's cinematic reflections on human intimacy go deeper into the ambiguous nature of intersexual oneness and possible happiness than anything Strindberg conceived.

In *Wild Strawberries* the hostility between the Almans is counterbalanced by the greater capacity of Evald and Marianne to overcome their difficulties, slowly perhaps but gradually. Marianne asks the Almans to leave the car because she says that their mutual hatred sets a bad example for the young people in it. It is equally upsetting for her as someone who must yet find a way to feel love toward Evald and somehow elicit it from him.

During all this, Borg sits quietly and says nothing. But in the next, and most troubling, dream we discover what has been going through his mind. After undergoing the pain of watching the happiness between Cousin Sara and his brother, which shows him what he has missed in his own marriage, he sits for an interrogation about his credentials as a doctor and professional man. The examiner is Alman, very calm now and correct in his bureaucratic manner. Borg fails in two respects and

is declared incompetent. First, he cannot recognize the
gibberish on the blackboard that purports to be the first
principle of the Hippocratic oath. Alman tells him that
it enunciates the forgiveness that a physician must re-
quest at the outset. He concludes that in Borg's practice
as a whole he has lacked the kind of compassion and
human contact that a doctor must extend to his suffer-
ing patients. Then Borg is asked to diagnose a woman
who is sitting listlessly in a chair with her eyes closed.
Borg reports that she is dead. Instead she opens her
eyes and laughs in a fiendish outburst, baring all
her teeth as if to indicate her propensity to doing harm.
It is Mrs. Alman, avenging herself in the dream as her
husband has also done.

Just before he enters the examination room, Borg
accidentally wounds himself when a protruding nail
cuts into the palm of his hand. It is the camera's way of
preparing us for the suffering that Borg, like Christ,
must accept. After he has been declared incompetent
as a professor and practitioner of medicine, Borg is
taken by Alman to a forest glade where he can perceive
his failure as a husband. We see a scene in which Borg's
wife has sexual intercourse with a man she loathes and
yet feels herself pathologically drawn toward, not un-
like the unwholesome bond that Alman and his wife
evidenced in the car. Apparently Borg has either known

about the past reality of this scene himself, or else imagined but subsequently blotted it from his memory. It returns now with devastating impact. But even this crushing nightmare has a beneficial effect. After he awakens, Borg tells Marianne that he has had a bad dream, though he imparts none of its details, and then finds that he can converse with her better than before. Their discussion brings them closer together. It allows Marianne to talk openly about Evald and the unborn child, and it nullifies her former belief that Borg cares only about himself, that he is always cold and selfish.

After Borg's wife has undergone her humiliating sexual encounter in the dream, she tells the man she has been with that her husband is the real culprit in this. She blames Isak and his aloofness for her misdeeds. Her utter scorn toward him complements the disappointment that his cousin Sara had previously voiced, as well as Alman's conclusion that Borg's lack of feeling prevents him from ever being a good or honest physician. In the course of the trip, however, Borg gets an emphatic vote of confidence when he stops at a garage to fill the gas tank. It is run by a former patient of his, when he lived in that rural neighborhood years before. The attendant and his pregnant wife, who seem happily married, sincerely praise the old man for the kindness and generosity he bestowed upon them, their

family, and their neighbors at the time he served them as the local doctor.

When Borg and the others reach Lund, he is ready to engage in the parade and inaugural ceremony that celebrate his life's achievement. The company of the youngsters, Sara and her male companions, has reinvigorated him, and so have the painful as well as the sentimental memories that were reconstructed by the dreams about his childhood in the family. The reliving of the past through dreams being a re-creation of it that films further embellish by means of special techniques, the dreams that Borg has experienced in the narrative fall into place as episodes within his voyage to greater understanding of what he is and has become.

In Bergman's screenplay for this movie, he included a scene that occurs before the festive proceedings in the university and through the town. It portrays a meeting between Borg and two academic friends who are also being honored that day. Their conversation is realistically spiced with the sarcastic and deflationary remarks of these seasoned professors who are too worldly wise to take the pomposity of the formal events at face value. I think Bergman did well to excise that scene from the movie. It would have lessened the dramatic contrast between Borg's earlier anxiety and self-doubt about whether he is worthy of the official recognition and his

ability now to receive it with appropriate dignity and satisfaction.

That growth in self-esteem, together with his renewed communication with Evald, as well as Marianne's saying that she truly likes him after all, has made his day. His being able to talk freely with them, and to establish a more humane relationship than before with his housekeeper Miss Agda, restores his faith in life. The meaningful smile on his face then occurs in the movie's final shot. Thinking back to his childhood in the summer place, he has just had an image of his cousin Sara leading him to a cove where his father is fishing and his mother is reading a book under her parasol. They wave to the old man in a final act of approval that he, like Bergman and everyone else, has been seeking all his life.

In other films the magicality takes a different form. There are no dreams in *Fanny and Alexander*, for instance, but several important sequences in it jolt us out of the realistic structure of the narrative. One occurs when Alexander meets Aron, the hermaphroditic individual secluded in Isak Jacobi's apartment. Since the youth is a male with the voice of a female, we are prepared for the eerie power that exudes from this person.

It involves an ability to read Alexander's mind and bring to the surface the violent hatred the boy feels toward his cruel stepfather. By means that defy the laws of nature, Aron arranges for the older man (and his incapacitated sister as well) to be horribly incinerated. The stepfather dies as Alexander secretly desired, but in a state of agony that the lad could not have imagined.

All this is presented as an occurrence ontologically equivalent to the earlier suffering of Alexander at the hands of his tormentor. In the chain of causation, the latter's death makes possible the happy ending that ensues not only for Alexander but also for his mother. She had desperately wanted to escape her husband but was too intimidated to try to do so. Having finally attained their freedom from the tyrannical conditions to which they were subjected, Alexander suddenly has a vision of his stepfather, wearing priestly garb as he did before his immolation, and equally arrogant. As he might have done previously, he raps Alexander sharply on the side of his head. We know that this augurs for Alexander a future of remorse ("agenbite of inwit," as James Joyce would have called it) that results from his having harbored murderous intentions, although he himself did not bring them to fruition.

What appears in this passage is not symbolic of anything but rather a narrative imaging that operates upon

us as directly as the nonmagical dimensions of the story. The same is true of Alexander's visions of his beloved but now-deceased father, who comes into view several times and presumably on his own. Though we may consider this apparition a kindly wayward spirit, he is not a ghost or harbinger of some transcendental realm that awaits us or anyone else in the future. Nor is he just the embodiment of Alexander's thoughts. He is a figment of the magicality of film that serves at this point to remind the movie's audience of the good life that in the story emanated from Alexander's father, and from his father's family, as contrasted with the misery that occurred after he died.

Throughout this book I will touch on other examples of Bergman's cinematic magic, but here I want to mention one stunning sequence of that kind. In *Saraband* the plot approaches its climax after Johan tells his granddaughter Karin that he will pay for her advanced training as a cellist if she agrees to leave her father's home and enrolls at a famous conservatory far away. Knowing that this will break her father's heart and possibly destroy his will to live, Karin deliberates. Instead of showing in a purely sequential fashion what she is likely to decide, the camera advances the narrative more inventively.

Immediately after the conversation with Johan, we see a close-up of Karin sitting at her cello, playing it apparently, though we don't hear that. We hear instead the sounds of militant determination in Bruckner's Ninth Symphony. That work appeared at the beginning of the sequence when Johan put a recording of it on the phonograph before Karin arrived. It continues after she has left and paused on the stairs outside, pondering his offer. The image of her playing the cello soundlessly is more than just an externalization of her thoughts. It is also a prediction of what will follow.

As the shot continues, Karin's image gets smaller and smaller within an expanse around her that fills the screen and is completely white, like the face of a white clown or other magical entity. At the center, she wears a formal dress instead of the casual clothes we have seen her in all along. Her hair is neatly coiffed, and she looks like a professional performer concentrating on the bowing of her instrument. We know that all this represents the option that she desperately wants and that her grandfather has said he will subsidize if only she effects the difficult separation from her father. As the Bruckner chords repeatedly assert themselves, strongly affirmative but also subtly persuasive, we surmise that Karin may very well take that heroic path. Her ever smaller

image finally evaporates in some approximation of infi-
nite distance. She is now beyond our sight, launched on
her personal voyage to whatever success she can attain
as an artist in outer space.

The imagery as a whole is a statement that Bergman
makes, without any verbal discourse, about Karin's
choice. The film later confirms our inference about her
probable departure (in response to an even better offer,
as it turns out). What we have just seen is fantasy, unre-
alistic except in the future advent of Karin at the cello.
The combination of visual and musical effects belongs
to her reality in the story, but mere verisimilitude has
been transcended by the brilliantly cinematic mode of
presentation.

Bergman's technical mastery of the many aspects in
which magicality can function as it does in his films is
firmly embedded in his thinking about their creation of
form and meaning. In a documentary that was made
during the shooting of *Winter Light* he stresses the im-
portance of that film's prosaic and even bleak realism,
which must pervade the camerawork as well as the
telling of the anecdote whose details he had heard first-
hand from a priest in an isolated village church. Further
on, however, Bergman shows the nuanced complexity

of his conception when he explains that realism alone is not what he wanted. After saying that in *Winter Light* he sought to "get up close to reality, to a very Swedish reality, a very naked and obvious reality," he qualifies that by stating that this must be done "without turning it into a news report."[5] He insists upon the difference between a neorealist document and a feature film such as his: "We're reflecting reality, and that reflection is meant to be so bewilderingly similar to reality that we lose any sense that it's actually a reflection. It will simply be there, the fact of reflection."[6]

This idea of a film reflecting reality is reminiscent of Jean Cocteau's rejection of the common notion that films are inherently akin to mirrors, whether things are being mirrored or one is looking into a mirror. In effect, Bergman enlarges Cocteau's assertion that mirrors have to learn how to be more *reflective*, more capable of providing insights about reality instead of trying just to duplicate it. Putting this fundamental principle to his own uses, Bergman adapts it to the special needs of a particular narrative. In *The Hour of the Wolf* the Max von Sydow character, who has been experiencing a nightmare perpetrated by demons in his soul, says to them: "I thank you, the mirror is shattered, but what do the fragments reflect?" The same words reappear fifteen years later in *From the Life of the Marionettes* during a

nightmare that the protagonist Peter has about his imagined murder of his wife. In reality he does not kill her, but the entire film is an extended reflection into what could have caused his later murder of a prostitute.

For *The Virgin Spring* Bergman used a "tone" that is completely realistic until the terminating segment. So too did he tell his cinematographer that the images of the Virgin Mary leading baby Jesus in their walk on the grass in *The Seventh Seal* must be filmed to make them look like any other mother and child. The miracle of the gushing water in *The Virgin Spring* alerts us to the fact that everything we have seen is a reflection strictly controlled by the aesthetic parameters of a religious legend. From the very first shots of that movie, when the pregnant girl vents her anger toward the family that disapproves of her sexual behavior, each scene and every event in the narrative has beguiled us with its surface realism. Along with all the rest of the naturalistic depiction of daily life in the fourteenth century, we observe the grief of the mother who has now lost her only child and the silent determination of the father as he gets dressed in warrior garb and then ritualistically flails himself in preparation for his slaughtering of the evil herdsmen shortly afterward. Only later, when the couple finds the body of the dead daughter and the father eventually repents his violent response, does the

tone transcend the neorealism that has been dominant until this point. Bergman establishes through the miraculous spring the reflective import of the realistic images we have been watching. We recognize then that they were more than merely realistic.

Bergman reveals the mythic purpose of this story in a manner that goes beyond his having the father promise to construct a chapel on the spot in penance for his killing of the relatively innocent young boy as well as his guilty brothers. When he had finished murdering them, the father looked at his two hands with dazed astonishment at what he had done. After the miracle, he holds up his hand as the offending member that performed the deed, and that he will now use to build the chapel. This alone alerts us to the fact that we have perceived the unfolding of a fable that is partly realistic but also designed to provide an explanation of how our body, and specifically that much of it with which we identify ourselves, can play its role in a universal search for moral and spiritual redemption.

The hand in the coffin that grabs the hand of Borg is repellent to him because he refuses to accept its relevance to the vitality he still experiences despite his age. In an interview with Bergman the interlocutor mentions that the director once said that he would like to learn how to draw a hand, as a means of getting close to

reality. In *The Seventh Seal*, made three years before *The Virgin Spring*, the grandeur of the Knight's playing chess with Death for the sake of gaining more time in his quest for a sign from God is ratified by celestial voices when he soliloquizes: "This is my hand. I can move it, feel the blood pulsing through it. The sun is still high in the sky, and I, Antonius Block, am playing chess with Death!" In itself, that remark alone reveals the magnificence of his endeavor, mortal as it is. The scene functions as a further reflection of, and about, the imagined reality projected on the screen. Moreover, the imagery of the hand provides Bergman with a major implement that he will deploy later in the plot. The hand with which the Knight has been moving the pieces on the chessboard finally saves the holy family by knocking those pieces out of place and so distracting Death's attention.

In other films, as I've already indicated in my comments about *Fanny and Alexander*, the magicality through which reality is being reflected rather than copied operates in other ways. At the beginning of *Persona* we see footage of early cinema, sometimes wildly animated drawings, sometimes bits of silent feature films, sometimes just the unwinding of cinematic celluloid. As an initial reaction, we interpret all this as the filmmaker saying to us: "Hey, what I'm showing you

is a *movie*, an art form that started with somewhat primitive ventures at the beginning of the twentieth century, and with the technology and types of expressiveness available then." But this prologue, as extraneous as it may first seem to be, is in fact a valid adumbration of the film that follows. In its poetic though odd and somewhat chaotic manner, the story deals with the nervous breakdown of an actress and the confused self-absorption that causes her suffering but also leads to her eventual recovery and capacity to return to normal life.

The entire plot of *Persona* can therefore be seen as a consecutive reference to the nature of the performing arts through which Bergman communicates to his audience in either a theater or a movie house. When we see cinematographers and others in the crew at work in their studio, near the beginning and again at the end as if in a closure of this gestalt, we are also seeing a portrayal of Bergman's team in the process of making the film we are and have been watching. Experiencing *Persona* from this perspective, and having remembered Bergman's fascination with the human hand, the disjointed images of the prologue make sense as something more than just his medium calling attention to itself.

The preliminary segment shows an unclothed, and thus exposed, young boy lying on a hospital bed in a room that contains nothing else. Time and again the

boy tries to cover himself with a sheet that is too small. His attempts to get himself under it are fitful and restless in a way that prevents him from sleeping soundly. The images that then appear being all related to moviemaking, we can readily perceive the boy as Bergman himself, as just the person he is or has become since childhood, and more specifically as the bearer of the cinematic imagination that has evolved out of his earlier experience. Like the filmmaker, and like Jof in *The Seventh Seal*, the boy is what Bergman calls a "visionary."[7]

At a crucial moment the boy in this movie gets out of bed and stands before a large white screen. With his hand he traces an arc across it that generates the enlarged faces of two women. The first one is the face of Liv Ullmann, who plays the actress in *Persona*. With the same manual gesture, the same use of his hand as a magic wand that by now definitely identifies him as Bergman the creative artist who makes motion pictures out of impalpable imagery, the boy then replaces her face with the face of the other principal female in the film (Bibi Andersson). As if to test, or complete, that miraculous feat, the hand then fabricates again the two human beings we will presently be seeing in the narrative.

By way of contrast, Marianne's nightmare toward the end of *Scenes from a Marriage* causes horror in her

because she suddenly finds she has no hands and therefore cannot grasp the people she loves. In *Cries and Whispers* Maria looks in the mirror and exclaims that she cannot see her hand in it. In that film too, Karin holds up her hands at one point and ascribes her dominating nature to the fact that they are too large and want to be in command. In Bergman's adaptation of the libretto that Schikaneder wrote for *The Magic Flute*, Pamina has no such problems when Tamino is with her. She holds his hand as they go together through the water and fire of the third trial. She had failed the previous test, after which her love immediately disintegrated into suicidal despair. But now, with Tamino's hand in hers, she can surmount her personal shortcomings through oneness with him. Describing his creative process in the making of films, Bergman reports that the idea of *Persona* came to him after seeing two young women sitting together comparing each other's hands.

In the movie, the boy's astounding wizardry culminates with a concluding shot of the two female protagonists juxtaposed in a combination of their faces, momentarily joined as if to suggest the possibility of some kind of merging between them. The images flit by, however, and what they may have signified will have to be disclosed later in the film, when the merging

is highlighted and fully accomplished. At this prelimi-
nary point its meaning is obscure. It operates mainly as
suspense of a non-Hitchcockean sort that thrusts us into
the story that ensues.

Relying upon the magicality of film, and the arcane
power of the magic-making hand to express our deep-
est feelings, much as a painter does with a brush or an
author with a pen, Bergman's work may be taken as
filmic poetry akin to these other activities. But unlike
Cocteau, Bergman himself rarely describes his creativity
in that fashion. The sister art to which he usually aligns
himself is instead music, and, above all, the music of
Johann Sebastian Bach. That finally becomes a living
force and virtual character throughout the progression
of *Saraband*. At the beginning and then as the introduc-
tion to several of its subdivisions, repeated bars from
Bach's Fifth Saraband provide a sense of continuity that
links the successive episodes. The fuller statement of
this work, played by the young cellist in the movie's
climactic scene, signals the completion of her direct
involvement in the story.

In *The Silence* Bach's music makes a cameo appear-
ance. Apart from its being heard, which happens only
briefly, it enters the narrative when the hotel waiter

carries a radio into Ester's room and tries to ameliorate her sadness by playing Bach's music. It had been used in a comparable situation in *Through a Glass Darkly*. When the young woman in that film reads her father's diary and discovers that her schizophrenia is considered incurable, her sense of doom is soothingly supported by the strains of Bach's D Minor Cello Suite.

In *Cries and Whispers* his music plays an even greater role. After Karin and Maria in that film have vented their mutual animosity, they try to console one another in a silent scene during which we see them touch each other's face but hear nothing of what they say. Instead, there is a long stretch of an unaccompanied Bachian cello which entirely covers the event. As if it could speak our language, the music tells us that—compared to its own reality—the inaudible words of the two sisters are just the making of empty sounds that are not credible and will not last.

Like Antonioni's early movies, which Bergman found intriguing, *The Silence* dedicates itself to the misery and nothingness of having lost faith in everything. For Bergman this means being condemned to living without a belief in some paternal God whose voice we cannot hear, either literally or through appointed intermediaries. Being itself a beautifully well-constructed

work of art, and as engrossing as the great Italian neorealist films of Fellini and Vittorio De Sica, *The Silence* uses Bach to provide a slender ray of optimism about a world that can still have access to the aesthetic goodness his music has created. At one moment in his life, Bergman wanted to take a year's leave of absence from directing in order to study the art of Bach, and he performed in public a Bach cello sonata at least once. Since so much of Bach's work functions as religious music to be heard in church, one might say that Bergman's fascination with it is related to his father being a pastor and strict adherent to the dogmas of Christianity. Bergman was surely aware of that.

In *A Little Night Music*, Stephen Sondheim's musical variation on narrative themes in *Smiles of a Summer Night*, Egerman's son (the troubled seminarian) plays the cello rather than the piano as he does in the movie. I imagine this as a subtle homage to Bergman himself. I will return to the relationship between Bergman and his cleric father when I discuss the place of religion in his movies. Here I want to examine further his thinking about film as a kind of visual music.

Asked in the interview on *Winter Light* about his mode of shaping the form in his productions, Bergman replies in language that applies literally to music and only metaphorically to film. Referring to the pacing of

the shots in *Winter Light,* he states: "The basic tone is very difficult as we search for precise pitch at every moment. . . . Somehow there is an emotion that evolves, emerges, swells, and then gathers again. There's one emotional pitch right from the beginning. It's easier when you have different emotional levels, because there is a rhythm, a breath, to build contrast with. . . . It's hard to describe a tone. Maybe it's a solo partita by Bach— that's the only thing you can compare it to. It requires that kind of precision and presence the whole time."[8] In *Autumn Sonata* we hear a performance of an entire Bach composition for solo cello, occurring in a flashback that illustrates what is being described by a character as part of a life-determining event in the past. In that film we also hear two performances of the same piano prologue by Chopin.

Because he is acutely sensitive to film as a quasi-musical phenomenon, Bergman—more than any other director I know of—recognizes the utility and the importance of restraining all sounds on occasion for purely aesthetic reasons. At the beginning of *The Silence* and recurrently later in that film, we are presented with a world without music in its daily life and with extremely little of the noise we take for granted in modern times. The images are realistic enough but they exist in a context that evokes the feeling of a nightmare whose

infinitely quiet eerieness creates anxiety and even fear, as they do in someone who is having a bad dream. The effect on us is different from that of watching silent films. Those are often filled with noise, and even music, that our schooled imagination provides as appropriate, though imposed, accompaniment to what we see.

In *The Silence* as well as other films of Bergman—for example, in the silent crowd scenes at the beginning and the end of *The Serpent's Egg*—what appears on screen exists in a metaphysical void, an emptiness that instigates horror at the absence of meaningful sounds to which we are accustomed. In the coffin sequence of *Wild Strawberries* the unreal silence conveys our universal trepidation about death as the total loss of the life we know. But in *The Seventh Seal* Bergman's approach is subtler and more highly modulated. That film begins with loud and strident chords, first orchestral and then vocal, that descend menacingly from heaven. These are the sounds of God in his frightful glory. Yet they are quickly followed by a silent image of a stationary bird that has spread its wings above the ground below. Then a voice reads from the Book of Revelation.

Earthly noises enter once we see the Knight and his squire on the seashore. When Death suddenly appears, all sound is eliminated, even the crashing of the waves

on the strand. As we traverse the barren terrain in the company of the Knight and the squire, music occurs only when it serves a special purpose in the drama. We hear Jof and Mia sing as they dance on stage, the flagellants as they voice their self-hating chants, and also that celestial choir that intones its approbation of the Knight and his sacred quest. Otherwise there is little sound to enhance or interpret the narrative. The evolving plot, like the humanity that Bergman depicts, is on its own, alone in the plague of aesthetically unadorned existence.

Much of the greatness of *The Seventh Seal* derives from the alternation of sound and silence, the steadfast and rhythmic tessitura in this unified relation. Having begun with the mise-en-scène of God's presence, the movie culminates with the silent dance of death that Jof observes at the end, as opposed to the boisterous dance of life that he and Mia performed on stage. When they and the baby proceed on their way in the closing shot, there is no music. In their family love they have got beyond that, while also escaping for the nonce the nothingness of death. Bergman's screenplay describes the patter of raindrops falling on their wagon's canvas cover and the song of a bird that greets the morning air. We do not see or hear any of this in

the film itself. But we know that the holy family is setting forth into the blissful sunshine of a new day. No sound effects are needed for that mythical and magical conception.

In *Smiles of a Summer Night*, we are blasted more than once with loud and raucous tutti in the orchestra, which signal a mammoth shift of the plot when they intrude. In their blatant vulgarity, they accentuate the fact that so much of that film is sheer entertainment, albeit within a sophisticated setting. At the opposite extreme, Bergman's love of music, and his insight into its vital role in a theatrical as well as in a filmed performance, shows itself to perfection in his version of *The Magic Flute*. Bergman had Mozart's score to work with, of course, but his presentation of it, on a stage at first and later before a movie camera that takes us into its own domain beyond the theater, is wonderfully imaginative at every point.

In an early scene, the three ladies of the queen hover over the prince, who has passed out after being attacked by the fairyland dragon. While singing about his beauty and expressing sexual desire toward him, each of the ladies in her own acting style smiles seductively at the audience. They are vying for affection from

the public as well as from the handsome though still unconscious young man. But toward what audience are they directing their coy and cunning glances? They are standing on a small stage comparable to the one on which the original Mozart production may have taken place during the last decade of the eighteenth century. Bergman allows us to believe that they are looking out at the patrons in that kind of theater.

At the same time he does not ignore the fact that the women are being filmed before a camera crew and, above all, a director whom they want to please in any way they can. Especially in the tight close-ups, and therefore unavailable to people at a live performance whether or not they are looking through opera glasses, this self-reflexive aspect of what is going on creates a splendid cinematic enrichment. In many places within the subsequent film, Bergman invokes a similar ambiguity with unfailing inventiveness. As another example of his inspired and playful directing, not only do we see the Papageno singer backstage before he enters the action and other performers later relaxing during the intermission—a shtick that Bergman may have borrowed from Olivier's *Henry V*—but we also watch members of the crew doing their work while the production is progressing or else playing chess until they are needed to carry out their duties.

In comments that accompany the DVD of this movie in 2000, Peter Cowie remarks, "Twenty-five years after its first appearance, Bergman's film of *The Magic Flute* remains the finest screen version of an opera ever produced." Whether or not this is true, what Bergman offers is a type of opera film that few moviemakers had attempted before him. It is a rendition that specifically hews to what is shown and heard in opera houses while using the camera as a means of delivering the director's interpretation and perspective as in a feature film of his own. Though there may be some pretense of recording an authentic stage production, as at first in Bergman's movie, the genre normally goes far beyond that. Following Bergman's lead, masters in this art form include Joseph Losey (Mozart's *Don Giovanni*), Petr Weigl (Britten's *The Turn of the Screw*), and Jean-Pierre Ponnelle (Monteverdi's *L'Incoronazione di Poppea*). Not all film and music critics will agree that Bergman's opera movie should be considered "the finest... ever produced."

Even so, the great success of Bergman's *Magic Flute* forced theorists as well as directors to reconsider some of the stock ideas that continually recur in the art of both film and opera. Bergman systematically violated principles that had governed previous assumptions about the aesthetic possibilities of these media. He sub-

ordinated the music to the drama, largely reformulated as cinematic drama, and even prevented us from seeing the orchestra. Wagner had relegated the orchestra to a sunken pit, but he did so in order to enlarge the action of what is performed on stage. Bergman shows us an appropriate stage and he films events that occur on it, but his camera freely peers at the behavior behind it I have mentioned in order to remind us of the humanity from which such operatic productions emerge. When we first see Papageno, he is awakening from a very Papageno-like snooze just in time to rush out and take the cue for his opening lines. We later watch the Papagena actress pleading with one of the priests to allow her to make her appearance at that moment in the disguise scene with Papageno. In his performance onstage the priest himself is given personal gestures that had never been imagined before. If, as Mozart believed, the poetry in an opera must always be the "obedient daughter" of the music, how can his singspiel accommodate these typically cinematic devices?

Moreover, opera has often been defined as a dramatically unsubtle art form that has to make itself accessible to the last man or woman sitting in the last row of the highest tier or balcony. In a sense this requirement is fulfilled by the magnification belonging to the photographic image itself as it looms over

everyone in the theater with a magical enlargement that no living performer can ever emulate. In reaction to this characteristic, Bergman uses many close-ups, as he would have for any other kind of movie. They are not spotlights that call attention to the fact that someone is singing an aria, but instead they portray the facial gestures that express the character's feelings. On the stage no performer would deploy his or her features in the same fashion, and many of the greatest opera stars could not stand up to the delving of Bergman's camera. Through close-ups in general we perceive the multiple meanings of the human visage. But how can this be compatible with the lyric grandeur of the human voice?

There isn't any answer to these questions, and they can easily degenerate into philosophical queries that are based upon contrived presuppositions. In themselves artistic media have no limits that are discernible in advance. Nor can their potentialities be known until a superior artist comes along to show what can be done by actually doing it. The opera-movie could never be the same again *because* Bergman filmed *The Magic Flute* precisely in the way that he did. He proved that it can be more than just the filming of an operatic perfor- mance, and more than just a realistic production in which people sing against the background of some hidden orchestra while otherwise enacting an ordinary

movie. Bergman used his camera with the same kind of audacity Mozart allowed himself when he adapted eighteenth-century stagecraft and music making to the necessities of his own unique talent as a composer.

In *The Magic Flute*, as in Bergman's other films, his characters often talk in a whisper. It renders their utterance into the dramatic suggestion of a soliloquy or interior, voiceless, monologue. We think of their discourse as possibly being components, frequently diabolical, within a single personality whose moral complexity we must infer. In *The Magic Flute* Bergman has Monostatos whisper slyly to Pamina when he encourages her to take arms against Sarastro as her mother had demanded. This immediately gives Monostatos a three-dimensionality that he rarely has in staged presentations of this opera. And having modified him to this extent and in accordance with his cinematic conception, Bergman had to change the other manifestations of Monostatos's character in order to render him reasonably consistent. For instance, his first encounter with Papageno was written by Schikaneder as a moment of farce, the two of them cowering in terror on the assumption that anyone as strange-looking as each is to the other must surely be the devil. But that effect clothes Monostatos in the innocence of low comedy, thus destroying the more somber interpretation of his

being that Bergman wanted to emphasize and would subsequently develop. He therefore blithely alters the nature of the scene, leaving the music relatively intact but eliminating the words and stage business that would have accentuated its inherent humor.

Bergman's basic approach to the Mozart film emanates, as in all his movies, from themes out of his own life whose realistic details he transmutes into strands of imagination that become fictional entities comprehensible through his art. While also constructing a work that can be enjoyed without any knowledge of the artist's personal history, this bivalent showing forth of oneself may be characteristic of aesthetic creativity in general. But, as I have suggested, Bergman does it better, and more often, than almost any other moviemaker. Combining his love of music, theater, and film in this version of a great opera, Bergman had only to reorient slightly the same methodological expertise that he deploys in other types of film.

In its own way, Bergman's *Magic Flute* provides an answer to some of the problems posed in *Autumn Sonata*, released three years later. The gripping drama of that film arises from the relationship between an

internationally acclaimed concert pianist (Ingrid Bergman) and the musical but musically ungifted daughter (Liv Ullmann) whom she has neglected from childhood. While the place of music in a visual art such as film is never broached, the question of music's enormous importance in human life is implicitly being judged throughout the suffering and unfulfilled love between mother and daughter. The former is accused of having crushed the affective being of the latter through a self-centered dedication to this difficult and demanding art, but what hovers above their traumatic situation is the possible immorality of music itself. Is it worth all the sacrifices that it requires of people who give their lives to its ideal perfection? Can one truly pour authentic emotion into the creation or performance of musical compositions without impairing one's ability to retain it for intimates one may also want to love in some sense or other? And if one fails them when their needs as young children conflict with the exigencies of professional devotion to the magnificence of music, is one not guilty of inflicting unjustifiable sacrifices upon the innocent creatures who have been dragged into the artistic maelstrom?

Neither Mozart's opera nor the conception that Bergman puts on-screen offers explicit answers to such

questions. But in the extended affirmation of marital harmony that Mozart intimates and Bergman greatly elaborates in the finale of *The Magic Flute*, we are encouraged to think that in principle, at least, some happy solution can be found. *Fanny and Alexander* celebrates the theater as a homeland for art that lends itself to the growth and joyfulness of family love. In *The Magic Flute* that service is performed by the very music we have been hearing, and implicitly by music as a whole. We are frequently reminded that the flute is magical in itself, as all music may seem to be, and that through the magic of music even the agonies experienced by the protagonists in *Autumn Sonata* can somehow be overcome. With his unrelenting perception of the miseries in human relations, Bergman was supremely qualified to envisage that elusive path of salvation.

Having said all this, I also see the merit in criticism of Bergman's *Magic Flute* that Herbert von Karajan pronounced and that Bergman quotes in *The Magic Lantern*: "'I saw your production of *A Dream Play*. You direct as if you were a musician. You've a feeling for rhythm, the musicality, pitch. That was in your *Magic Flute* too. In parts it was charming, but I didn't like it. You'd switched some scenes at the end. You can't do that with Mozart. Everything is organic.'"[9]

Eight years before he made *The Magic Flute*, Berg-
man used it as a dramatic event in *The Hour of the Wolf*.
It appears as a divertissement during the aristocrats'
garden party. Though all the persons there except
for the von Sydow and Ullmann characters are damned
to some personal perdition, they nevertheless enjoy a
recording of the Mozart opera in a marionette theater
set up for the occasion. Its delicate music serves as an
ironic counterpoint to the unhappiness of these lost
souls. They are themselves pitiful marionettes, as in
Bergman's later movie *From the Life of the Marionettes*,
and shortly after they hear the opera, we see them
squirming on top of each other like the doomed inhabi-
tants of the cavern through which Tamino and Pamina
must manage to pass in the trial of fire and water.

A feature of Bergman's individual talent that critics
have often noted is his expertise in using the camera for
zoomed-in fixations upon the human face. In one of his
interviews, Bergman says: "I think that the cinematog-
raphy of the human face has brought to us the most fan-
tastic thing that we can see in art. That is, the human
face in movement. . . . We sit there, and we can see the
thousands of muscles here around the eyes, around
the lips. We can see how the blood comes and goes

in the face.... I am mad about the human face ... and if I want to study the human face, the background has to be quiet and to shut up."[10]

This predilection applies to the boy's scanning the huge close-ups of the two main characters in *Persona*. Their enlargement on the screen shows forth the personality that each of them has individually, and finally shares with the other. In this introductory presentation we see only their faces, but in total, fully engaged shots that renew themselves over and over again as the two women—in either the linguistic flood of the Bibi Andersson character or the catatonic silence of the one portrayed by Liv Ullmann—reveal what kind of persons they are. No filmmaker since the early Carl Dreyer has focused upon the actors' faces with an intensity similar to Bergman's in almost every one of his films. And no one, including Dreyer, has equaled Bergman in eliciting from the performers as vast and variegated a panoply of feelings, which often express themselves in gestures that are extremely meager.

Being a man of the theater, Bergman understood, more than many others, how to combine its aesthetic virtues with those of the cinema. Through their magnifying capacity movies can show us facticities that lie beyond the visual apprehension of spectators watching people on a stage. That being the fundamental nature

of film, the *meanings* of the faces it projects are normally conveyed most effectively by the slight though relevant responses within a cinematic situation. All filmmakers know this, but very few have learned how to structure each frame accordingly, and how to derive from the actors the requisite skill of communication. Bergman, alongside the cinematographers he worked with, created masterful shots of the human face because he excelled in viewing it simultaneously as both a man of the theater and a moviemaker.

This special achievement of his work is most evident in what he called "chamber films." The terminology is an extension of the phrase "chamber music," but it also applies to stage performances in which few, sometimes only two, three, or four, characters appear before the public. Strindberg called his similar productions "chamber plays." In Bergman's films the drama consists in the explicit interaction between themes and personalities that can arrest the interest of an attuned audience and direct it toward the multiplicities that emanate from the diverse being of the characters. It is in the nature of our anatomy that the face is the most obvious icon of our personhood. From it issues the voice that articulates our language, and in it reside the organs of sight and hearing as well as speech. Chamber films capitalize on the great plurality of effects

that coalesce in watching the facial expressiveness of a
very small number of protagonists.

Bergman's use of close-ups in large-scale films—
Fanny and Alexander, for example, or *Wild Strawberries*—
serves the same type of function as in chamber films
like *Through a Glass Darkly* and *Cries and Whispers*. The
relative failure of *The Serpent's Egg* can be traced to
the futility of providing so many close-ups of the vapid
main character, played by David Carradine, in a very
large-scale movie that tries to make a sociohistorical
statement. To some extent Bergman compensates for
this shortcoming, however, by inserting shots of the
faceless faces of those masses of demoralized men and
women who slowly shuffle toward us, sheeplike and in
silent slow motion, at both the beginning and the end of
this film.

The faces we see during the overture to *The Magic
Flute* are the very opposite. Sitting in their seats and lis-
tening to the music without talking, they have features
that are immobile and inexpressive but are nevertheless
suffused with the sonic intelligence that Mozart purveys
to everyone who can savor the notes he has written. In
his display of the faces during the overture, Bergman
was making a preliminary declaration about the rele-
vance and universal accessibility of the Mozart master-

piece. Rather than filming much of the audience's response during the performance, which would have violated the rhythm of its presentation, Bergman gives the sheer attendance of those who listen to the overture a significant place in the movie. Throughout the film in its entirety they just sit still. Only once, toward the end of act 2, do the spectators turn their heads and squirm a bit, as a real audience might. Though the orchestral prelude complements the ensuing drama and music after the singers appear, our observing the faces of the audience alerts us to the *interhuman* vibrancy that the entire opera celebrates, like all other great music.

The Magic Flute being at base a simple fable that is directed toward younger as well as older people, Bergman's camera lingers on the faces of both children and adults. It returns repeatedly to the visage of one girl in particular, as if to relish her youthful apprehension of this tale about a hero's search for a princess he falls in love with after seeing in a miniature painting how beautiful she is. Neither the girl nor the people in the audience are especially beautiful. Far from that, their rigid postures and concentrated faces make them look like members of a congregation in a religion that demands mechanical obeisance to some official doctrine.

For that reason alone, Bergman's stationary camera during the overture might seem to undermine the liveliness of this work of art. What we see after the curtain goes up is often comical and superficial, though also pure-minded in its childishness and spiritual in the values it professes. There is nothing static in the music of either the overture or the opera itself, and in that sense nothing like the stolidity of the well-behaved listeners. One can therefore say that Bergman is establishing an insightful counterpoint between the vivacity of the music and its unimpassioned reception by the audience. This in turn serves as a commentary on the paradoxical character of all such aesthetic experience, self-reflexively made through the motion picture camera whose controlled and mechanical creativity cannot be duplicated by those who perceive what it produces. The camera studies the faces of people who, in this case, have access to one of the greatest pleasures that human beings have acquired, and yet these persons show little or no sign of their actual enjoyment. At the same time, and also thanks to the mediation of the camera, we who watch the film are rendered face-to-face with these nameless individuals, whose immersion in Mozart's opera we share both directly and secondhand.

Other major functions result as well from Bergman's filming of the spectatorial faces in *The Magic Flute*. The

young girl is more than just a member of an audience. She, and she alone, smiles occasionally or shows incipient feeling in appreciation of what she sees. The camera lights on her at the very start and then returns to her time and again. She thereby represents everyone else who is present and entranced by this opera, whether in the theater within the film or in a movie house looking at a screen, or at home sitting before a monitor. To that extent she unites us all.

The other faces, captured in the uniform act of merely looking forward placidly as the camera records their great variety of ethnic colorations and personal features, could very well belong to people who are sitting for their portrait one by one and in a group. They constitute a simulacrum of the human species itself, the love of which is extolled throughout Mozart's Masonic opera. In writing his libretto, Schikaneder incorporated an enlightened eighteenth-century acceptance of the Judeo-Christian mandate to love one's neighbor as one-self. This implies that all human beings are to be loved in some moral and inclusive manner, but in its religious generality the injunction does not specify who exactly are the many people lumped together in this conception. It provides no clue to what they look like. Bergman's camera remedies that omission. It shows us the plurality of their faces as well as their oneness in jointly

attending this performance. In the film they become an aesthetic community devoted to music as a holy ideal (as Schubert calls it in "An die Musik") that reciprocates by declaring in *The Magic Flute* the love of persons like those being photographed.

The idea of film as an active intermediary also appears in the title of one of Bergman's movies about marital and personal disintegration, *Face to Face*. The term suggests emotional confrontations that can be as painful to people exposed to them as hand-to-hand combat would be. The camera enables us to experience the calamity from the point of view of the adversaries. In its realistic stance it serves as an impartial spectator of the conflict in which individuals cannot face up to their interpersonal difficulties. It is also possible, however, that Bergman's title is an ironic, even sardonic, reference to the ultimate truths that Saint Paul promised when he told the Corinthians: "For now we see through a glass darkly, but then face to face: now I know in part, but then shall I know even as I am known."

Something comparable can be said of Bergman's psychodramas in the 1970s and 1980s, starting with *Cries and Whispers* and ending with *Autumn Sonata* and *From the Life of the Marionettes*. They are all constructed

face-to-face, often as lengthy dialogues between two people, and they rely extensively upon close-ups of faces that disclose what is happening in a character's innermost feelings.

As early as 1958, Bergman had given the title *The Face* to the movie known in America as *The Magician*. Its plot poses a battle between scientific and aesthetic attitudes toward life. At the end the performing artist (enacted by Max von Sydow) who has mesmerizing powers loses face and is exposed as largely fraudulent. When Bergman later directed Molière's *Tartuffe* onstage, von Sydow—in the title role in that production—wore the same makeup as in *The Magician*. Both characters are cheats of one kind or another. But though the mountebank in the movie turns out to be a piteous creature once the awe-inspiring pretense of his theatrical face has been removed, he survives with a triumphant fanfare of background music when he and his troupe are invited to appear before the royal court.

Before that happens, the grim and silent expressiveness of his face, heavily enclosed in long and fake black hair that causes him to look like Rasputin, have a magical impact in their otherworldly outlandishness. Exploiting that effect, the player manages to outface and humiliate the doctor who espouses a scientistic approach to life common in the nineteenth century.

Science finally emerges in this film as vindicated within its own dimension, but chastened nevertheless. Though the later psychodramas are less pleasant to watch, they are more ambitious, and possibly more telling as manifestations of what a face can reveal about the human condition. In one form or another, they are all mythic in scope and supremely adept in their use of cinematic magic.

For Bergman the hand and the face are principal tools in what he describes as his workaday craft. In one interview he explicitly compares himself to a carpenter or other laborer who fabricates articles of utility that serve a practical need within a limited context. He ridicules the suggestion that he makes his movies with some greater end in view. They exist here and now, he says, and for people in the present who may possibly benefit from them. In a confession that seems to me characteristic of highly successful men and women, he asserts that his former achievements mean scarcely anything to him. Their day is past, and he claims to revisit them only on special occasions. In *Whatever Happened to Baby Jane?* the Joan Crawford character lives mainly in recurrent memories of her youthful successes as an actress,

rewatching her old movies again and again. That way lies neurosis destructive of anyone's vitality, Bergman argues. In proceeding as he has throughout his life, he demonstrates the ability of the creative mind to prolong as well as further whatever may arise from the unresolved challenges of one's profession. Whether in relation to an artist or a craftsman, and most great filmmakers are both at the same time, implements like the two I have just mentioned are practical resources that imagination can always use productively.

As I have suggested elsewhere, imagination itself is best understood as a capacity to entertain possibilities of every sort, whether they are empirical, technical, moral, logical, or even self-contradictory.[11] In Bergman's work these all appear in the motifs that we have been discussing, and through the mythologizing magic of cinematic art. Near the end of *Fanny and Alexander*, Bergman explains his penchant for mixing the possible with the impossible or, more often, with what is only possibly possible. Having survived her unfortunate second marriage, Emilie returns to the theater that her first husband had made a source of happiness and communal value for their family, their friends, and their society at large. She will once again perform in public, and her mother-in-law, Mrs. Ekdahl, herself formerly a leading

actress, will be in charge of the theater. As an initial effort, Mrs. Ekdahl decides to put on Strindberg's *A Dream Play*. Bergman had directed and been enthralled by it throughout his career. In *Faithless*, there is a scene that includes a rehearsal of *A Dream Play*. Almost as a coda to *Fanny and Alexander*, Mrs. Ekdahl reads aloud a little of Strindberg's "Explanatory Note" about his work. Bergman could very well have uttered the following lines of Strindberg as a proclamation of his own aesthetic outlook. They reach an apogee in *Persona*, but apply as well to his other films.

In this dream play... the author has tried to imitate the disconnected but apparently logical form of a dream. Everything can happen; everything is possible and likely. Time and space do not exist; on an insignificant basis of reality the imagination spins and weaves new patterns: a blending of memories, experiences, free inventions, absurdities, and improvisations. The characters split, double, redouble, evaporate, condense, scatter, and converge. But one consciousness remains above all of them: the dreamer's; for him there are no secrets, no inconsequence, no scruples, no law. He does not judge, does not acquit, simply relates; and as the dream is usually painful, less frequently cheerful, a note of sadness and sympathy for every living creature runs through the swaying story. Sleep, the liberator, appears often as painful, but, when the torture is at its very peak, waking comes reconciling suffering with reality, which however

painful it may be still at this moment is a delight compared with the tormenting dream.[12]

Stage plays often have difficulties when they seek to embody these characteristics. Movies not only accomodate them with ease but also draw mythic and philosophic meaning from them while also emulating the sharpness and precision that usually inheres in our perceptual faculties. Because they do not try to present either the factual reality of dreams or a copy of whatever factuality pertains to our dreaming state, the Bergman films are especially good at effecting this combination. Having lived as an artist with Strindberg's credo before him, Bergman offers his cinematic reflections of our being as a testament to his personal imagination that "spins and weaves" the patterns rendered to him by the techniques he has acquired.

As a means of understanding the actual dimensions of Bergman's imagination, it will be useful to compare his work with a recent film whose inspiration also deals with the nature of imagination. In Jean-Pierre Jeunet's *Amélie* (2001), which has had enormous international acceptance, imagination is presented in a very different guise from Bergman's. Splendid as it is in its cinematography, *Amélie* scarcely forces us to think about its mythic themes, whereas many of Bergman's movies

specifically require that we should do so. The Jeunet film joins the idealization of imagination with the much embattled but still resilient myth of Romantic love and its essential ideality. With the exception of *The Touch* and *Private Confessions*, Bergman's major films scarcely consider that.

In Amélie's wide eyes and winsome smile as she repeatedly looks out at the audience, we see the glory of her great imagination. It motivates most of the action in the film. At the same time, we never feel a need to probe either the sources of imagination in general or its creative operation in the experience of love. Whenever Amélie undertakes and then completes one of her brilliant feats, the screen bursts into colors and designs that are supremely vibrant. We all respond to the inventiveness of this, and to the wondrous fertility of these clever effects. They are directly linked to Amélie's search for a true and authentic love that is more than just a sexual phenomenon. As an illustration of her disappointment with sex alone, we see her in the act of intercourse, not savoring what is happening in her body but rather looking out to the camera as something equally mechanistic that can possibly register her predicament. Why it is that she keeps evading, though also seeking, the erotic consummations she really wants becomes a thread

within the narrative—in fact, a pervasive problem that she slowly but finally solves.

Amélie is led to her benign solution by the Man of Glass, whose bones are so brittle that he must stay indoors all day. He devotes his time to making one copy after another of Pierre-Auguste Renoir's painting *The Boating Party*. His is a type of imagination that responds to the imaginative creativity of an artistic genius. In the movie this process enables the Man of Glass to speculate about a young girl in the painting as analogous to Amélie, herself a creature of imagination, and in ways that help her discover the interpersonal imperfection that she must remedy. She ultimately succeeds by deploying her ever-active imagination in that endeavor.

With this as its lynchpin, the Jeunet movie has a fast-moving pace. Imagination that had previously worked against Amélie's desire for perfect love is readily converted at the end into a means of procuring the intimacy of sexual oneness. This approach to the nature of love has had a long and prominent history in Western cinema that Jeunet could count on as money in the bank. A large majority of moviegoers have always been happy to see on screen the tortured quest for interpersonal love as it leads to a desired catharsis

when it fails and to a joyful, even ecstatic, exuberance that everyone can experience vicariously when natural impulse wins out. It takes a daring innovator like Sturges to pose the subsequent question that occurs twice in *The Palm Beach Story*: *"And they lived happily ever after ... or did they?"*

Amélie and her friend cheerfully ignore that doubt. But do they stay together? Do they get married? Are they really compatible? Will their happiness last? In their case, we do not know and we do not care. At least, we have not been encouraged to. The comedic richness in the Jeunet film takes us only to the point where imagination and the Romantic ideal interpenetrate. The movie remains relatively simplistic: in its rapid excitement—marvelous as that is—it does not pause to open and inspect the concomitant issues.

Bergman reaches beyond any such approach to either imagination or human love as it exists in the real world. As Welles said of himself, he is an *examiner* of myths rather than one who makes or naively continues them. With respect to the myth of romantic love that underlies the fabulous imagination of Amélie, a powerful enunciation of Bergman's perspective occurs in *Faithless*. That is a film Liv Ullmann directed in 2000 but Bergman

wrote. Ullmann has said that after the years during which they lived together and produced a child, she and Bergman continued as coworkers and good friends though no longer lovers.

This film they created jointly many years later is an advanced statement of themes that are also intimated, though not fully developed, in other Bergman movies. Like them, *Faithless* deals with the search for love, but now it is envisioned through a version of the Tristan myth. Leaving aside any autobiographical details, we can clearly see how the narrative explores an affective triangle consisting of a functioning husband and wife whose close friend is a troubled man desperately needing the affection of both. The husband is like King Mark insofar as he is an eminent social figure, an internationally renowned orchestra conductor; the wife resembles Iseult in being a very attractive and outstanding actress on the stage; the Tristan personage, whom some critics have identified as Bergman, is a theater director beset with unspecified but terrifying devils within himself that have left him in emotional shambles after his previous turmoils of matrimony and divorce.

Starting with this mythic triangle that has provided the framework for hundreds, possibly thousands, of literary, theatrical, and cinematic productions, Bergman enriches it with a fourth character—the twelve- or

thirteen-year-old daughter of the marriage. As we saw, in *Autumn Sonata* Bergman had focused upon the damage done to her daughters by a mother who neglects them in order to pursue her career as a performing artist. The harm that a sensitive child can suffer as a result of her parent's chosen life hovers in the background of most of *Faithless*, and then takes center stage at the climax of the story. In other versions of the Tristan myth, during its seven or eight hundred years as a thriving legend in the West, the facts of childbearing and nurturance of the young had rarely been included as a complication within the quest for sexual and amatory consummation. Tolstoy's *Anna Karenina* is one of the exceptions, but there the protagonist's maternal love is not strong enough to keep her from committing suicide as a consequence of her erotic failure.

In Bergman's script it is not the mother who kills herself but rather the father. Unlike the ending in the traditional Tristan myth, the lovers suffer in later years, even more than during their relationship itself, but they do not die in each other's arms or together at the same time. Furthermore the father melodramatically tries to punish the mother by getting their daughter to accompany him in death. He asks her, unsuccessfully, to commit suicide along with him.

The original Tristan legend pitted the legitimacy of marital fidelity, as a staple of social rectitude, against the life-enhancing quality of passionate sexuality. Both were treated as undeniable values, though only the latter issued directly out of nature, represented by the love potion. In *Faithless*, however, pleasure or mutual endearment hardly enters into the dramatic circumstances. It is the pain and guilt of love that are mostly depicted. At the beginning the woman overcomes the hesitancy of her vacillating lover by saying their affair would be "fun," and we do see a bit of the adventurous abandon of their secret meeting in Paris. But for the most part, the history of their liaison serves as further exemplification of the refrain that runs through William Wyler's *The Heiress*: "Plaisirs d'amour ne durent qu'un moment/Chagrins d'amour durent toute la vie."

Faithless studies Romantic love from within a perspective that separates Bergman (and Ullmann) from any affirmation of its mythology. As a narrative contrivance, the story is presented by a writer sitting at his desk and conjuring up a woman of his imagination. In answer to his questions, she supplies information about the life she lived before and after the affair we then see as realistic reporting. In the course of it, she intervenes as the narrator who is relating the relevant events to the

writer. He sometimes asks for a clarification, but generally he listens in silence and with sympathy for the members of the triangle. Throughout the film it is as if he, being the fictional author of what will become the history presented to us, can foresee the final tragedy to which it is leading.

The author's name is Bergman (no first name supplied), and the actor who plays the part is Erland Josephson, a lifelong comrade of Ingmar Bergman who performs in several of his movies. The ocean frontage on which the old writer lives, and where he takes a solitary walk at the end, is located on Fårö, the small island to which Bergman retreated to write and make his later films. It is proper, therefore, to think of the author in the story as the actual writer of this film, who may possibly be drawing upon his own experience but at a time of life when he can aesthetically transmute whatever mythic role he may have played himself in the past.

Faithless is especially interesting not only as an imaginative account of the less than loving potentiality in Romantic love but also as a devastating statement of the sort that other Bergman films had also tended toward. Even *Smiles of a Summer Night,* which carries out positive intimations of comedies such as *A Lesson in Love* and *Secrets of Women,* proffers an unresolved ambi-

guity about interpersonal love which *Faithless* expresses more negatively. Though Egerman's son runs off ecstatically with his father's young wife, whose love for the son equals his love for her, *Smiles of a Summer Night* concludes with the sexual attachment of another kind that the servants Frid and Petra experience as creatures closer to material nature and the purely sensuous. They have little of the passionate craving that is idealized in myths like *Tristan and Iseult* or operas like *The Magic Flute*.

The likely postcoital marriage of Frid and Petra is an extension of the exhilarating pleasure to be found on a summer night in which one's hormonal urges attain their physical completion. In relation to Egerman's son as well as Frid and Petra, we have no idea of what their marital lives may be in the future. A warm summer night can lead to cold and wintry days. Both one's initial burning passion and the joy of sensuous sex may finally result in the misery that *Faithless* delineates. But all that is put in abeyance.

In the case of Egerman himself, we do not know at the end what his future may include. With the soot of the Russian roulette on his face, he has come to realize (painfully) that he knows little of love and that the best he can hope for is to reconcile himself to the quasi-maternal comfort Desirée will henceforth bestow upon

him. This emotional trajectory lends itself to good comedy or farce—"wise comedy" as this movie is sometimes called—but that cannot counteract the harsh and realistic debunking of the myth of Romantic love that later filters through every moment of *Faithless*.

In *The Touch*, the English-language film that Bergman wrote and directed for an American studio in 1971, he drew upon the Tristan myth in a manner that deployed his storehouse of cinematic techniques more extensively than Ullmann's directing of *Faithless* does. Twelve years later, however, Bergman called *The Touch* "a very bad picture. I think it was one of my worst pictures," though he also said that his screenplay is "a beautiful script. I don't dislike the script."[13] The movie is an updating of the myth, acted by Bibi Andersson, Max von Sydow, and other Swedish performers who are very much at home in the Nordic setting that Bergman has chosen for them. The Tristan character is played by Elliott Gould, whose antiheroic appearance and American diction suited Bergman's intention very well. The narrative is mainly seen from the woman's point of view. At the outset she is a bland and prosaic housewife, happily married, we assume, to a reliable and stable professional man similar to the one that von Sydow enacts in *Through a Glass Darkly*. After the

woman's routine existence has been dislocated by her mother's death in the first scene, she succumbs to the rough charm of the tall stranger with crowding teeth who announces that he is in love with her.

Gould's character, as he plays it, is a Bergman-type outsider, not only an unattached American in Sweden but also a restless Jewish intellectual whose family was annihilated in the German holocaust. He has previously tried to commit suicide, and in the course of their love affair he constantly flies into a rage, strikes the woman he claims to love, and disappears without informing her of his whereabouts when the fit is on him. Their tumultuous affair ends after her husband, like King Mark, finds out about it and repudiates her. She in turn concludes that though she loves her troubled Tristan as if he were a helpless baby he will leave her suddenly one day, sooner or later.

The Touch is superior to *Faithless* insofar as the passionate emotions that have created this sexual triangle are portrayed with all the fervor and erotic intensity that is foundational in the myth. As Bergman originally thought, Gould was the right actor for the role of David, and so was Andersson for her role as Karin. At the end, when she proudly walks away from her lover, pregnant with the child that either he or her husband

has fathered, we sense the suffering Karin has endured as well as the depths of womanhood that she has found in herself.

David, who is an archeologist, shows Karin an ancient statue of the Virgin Mary that has just been dug up. It has a lovely smile but cannot be preserved. Gnawing away inside, a colony of shiny black beetles is slowly corroding it. David plucks one of them with his fingers and, holding it in the light, he remarks about the beauty of this destructive insect. At the same site the camera lingers very briefly on a large crucifix with Christ stretched out in agony, and we know—perhaps too glibly—that despite the goodness or beauty that may belong to the love between these two people, it has been contaminated by the Romantic idealism that can only eventuate in profound suffering. Though Bergman may have wanted to do something more in this film, as it is it remains a viable and moving testament to the ambivalence he felt so strongly in that period of his life.

In *The Seventh Seal*, of course, there occurs an affirmation of marital love that places the narrative's mythic presentation on an alternative track. *Faithless* and its pessimistic forerunners among the Bergman films belong to the same genre of antiromanticism as Truffaut's *The Soft Skin* or *Mississippi Mermaid*—just to

mention two among many others in the latter half of the twentieth century. They all document the sadness and self-debasement that sexuality can often cause despite its libidinal or interpersonal allurements. The love within the artistic family in *The Seventh Seal* is completely different: it encourages us to believe that affective attachment can be not only natural and rewarding but even sacred. That possibility involves a wholly alternate kind of myth that Bergman examines through his visual and literary art. His thinking about it is inherently religious, and thereby implicates an aspect of his philosophizing that needs to be discussed separately. I will address this in the next chapter.

2

Religious Quandaries and the Nature of Love

In various interviews Ingmar Bergman outlines the personal bases of the work he did during his middle period. He describes being sternly indoctrinated as a child in the religion and repressive morality of his country's Lutheran faith; his yearning for communication with God, but not with Jesus; his feeling that the eye of God was always watching him from afar on a par with the remoteness of his ecclesiastical father; his being aware of his mother's love but not receiving much contact from her, and little of the emotion she expended toward propping up the neurotic weakness of his father; his debilitating sense of worthlessness that remained throughout his youth and into his early maturity; and his experiencing a resultant fear of human attachment and the natural impulses related to it, as well as a profound dread of death that (he then believed) could only lead to everlasting punishment for his misconduct as a

carnal creature. With that background of his sensibility, Bergman asserts that he used his cinematic work as a means of coming to grips with the affective as well as intellectual results of all these serious problems in his life.

I accept this report as honest and reliable evidence about the evolution of Bergman's genius and achievement. He tells us that his preoccupation with religious questions in *The Seventh Seal* dates to a time when he was terrified about death, about his own dying as an irreversible culmination to his life. He used the making of the film, he says, as a therapeutic device that might help him conquer his horrible sense of doom. This seems to me entirely believable, and also his statement that the mere completion of *The Seventh Seal* marked a big step in his search for emancipation from the horror he had felt about his mortality. Moreover, I think that with Bergman's self-analysis before us we can perceive how his early dramas, as well as the comedies, were often veiled projections of the mythic and religious elements in the subsequent movies for which he is best known.

Before continuing my line of reasoning, I want to map out the development of Bergman's cycle of quasi-religious movies during the 1950s and 1960s. *The Sev-*

enth Seal was filmed in 1957, immediately after the financial and critical success of *Smiles of a Summer Night* had enabled Bergman to produce works of his own choosing with much greater freedom than before. The ambiguity that structures *The Seventh Seal* has been seen by some as a means of mollifying adherents to the radically opposed views on religion that are pitted against each other in the narrative. But though this is true, the debate had been raging for some time within Bergman himself. The greatness of his film appears in the authenticity, and the clarity, of the conflicting attitudes that are represented, and in the visual beauty of their articulation in scene after scene. All the later Bergman films follow a similar approach that becomes more and more refined in its delineation as Bergman's thinking progressed.

This ambiguity bursts upon us in those contrasting shots at the beginning of *The Seventh Seal*. After the initial upbeat of the swelling music, the chorus—mainly female in a high register—intones briefly in an assertive but ominous rhythm. The sounds issue from a bright cluster of sunlit clouds surrounded by darkened ones that seem to be closing in on them. The bird that hovers in silence with its wings outstretched is, however, a comforting image, and so is the voice of the man who reads the passage in the Book of Revelation.

We are never told who the reader is, or from what location the reading comes. We may surmise, however, that it is part of a sermon that a preacher might deliver as a message from God. That was the origin of Bergman's struggles with the Christian dogma from which he tried to liberate himself in his youth. It is a suitable setting of the scene, both for the fourteenth century in plague-ridden Sweden as well as for the unsettled relation between Bergman and his father's creed.

Of equal importance is the fact that we cannot know what the bird is and what the opening bit of music signifies. Is the latter mainly a theatrical effect, like the pounding of the baton onstage that is used to arrest the audience's attention at the beginning of a performance? Is it a foretelling of some cosmic event like the grand explosiveness that announces God's miracle in making the world, as in Haydn's *Creation?* Or are the strident chords a declaration of the dreadful, pestilential, condition of mankind, portrayed in the medieval setting but also present in our modern life?

Similarly, the bird may be seen as either a predator or as proof of the deity's abiding love. Most commentators call it an eagle, while others refer to it as a hawk. Both species are predators. Despite its size, however, the bird's outstretched wings and the fact that it merely stays aloft and hovers, instead of flying in attack upon

some object, suggests the mythological dove that is said to descend in compassion for the sinning world. This in turn would adumbrate the appearance of Death shortly afterward, when he spreads his arms as if to embrace within his open cloak the Knight who has lost the appetite to remain alive. Taking him in death could be seen as an act of love or mercy.

The difference between these alternatives is as great as the difference between black and white in this as well as other Bergman movies. In answer to a question about his avoidance of color film until late in his career, Bergman states: "I think black-and-white is the most beautiful color that exists for our minds, for our creative minds. We are involved in the creative process when we are looking at a black-and-white picture."[1] He means that black-and-white movies force an audience's imagination to participate massively in the communication with the filmmaker and his images, which defines the nature of cinematic art. At the same time, we may add, black and white stand in maximum contrast to each other, and are therefore more dramatically confrontational than any other combination.

Starting with that premise, Bergman's all-embracing ambiguity can show itself in the sheer whiteness of the face of Death, the only character in *The Seventh Seal* who is purely mythical and not at all realistic, though his

function in life is. Commenting on his film, Bergman explains the color of Death's face by saying that he had in mind the white clown in a circus. In *Sawdust and Tinsel*, whose Swedish title is more literally rendered as *The Clown's Evening*, the ever sad-looking clown appears recurrently in whiteface. To that extent, Death belongs to the same or equivalent profession as the other players in *The Seventh Seal* who also perform with faces painted white. His whiteness is akin to the color of the hovering bird, white apparently though darkened in its position beneath the menacing clouds. Unlike the images of Death in *Prison* (*The Devil's Wanton*) and in the clock tower of *Smiles of a Summer Night*, this Death is not entirely frightening.

On the contrary, he is often jolly and even witty. He accepts the Knight's proposal to play chess with the responsiveness of someone who really enjoys the game and prides himself on being a master at it. When by chance he is assigned the black chessmen on the board, he jokes about that being quite suitable for someone with his occupation. Collecting the life of Skat, the lecherous actor, he cuts down the tree branch on which Skat had climbed in order to escape the jealousy of the blacksmith. As he saws away, Death toys with the man in a lively exchange that makes Skat's excuses for staying alive seem as ludicrous as they would be in the

circus or a comedy. When Skat pleads that he has to give a performance, Death replies that it's been canceled because of death. When the player persists by adducing his contract, Death wryly answers that it has been revoked.

This laughable manifestation of the divine comedy that pervades our purposive being in nature does not diminish Death's unrelenting devotion to his mission. Even when he cheats at chess by playacting as a father confessor, also hooded in black, Death is simply doing his job as one who belongs to the dark side despite the complementary whiteness of his humanoid disposition. Soon after Death first visits the Knight, we see the gruesome remains of a man on the beach who has died of the plague. They are not at all white.

Throughout the ambiguous characterization of Death he retains an adherence to the virtue of telling the truth, which Bergman considers fundamental in a good life. When the Knight asks whether he will divulge his secrets at the end, Death answers that he hasn't any: "I have nothing to tell." And, of course, he doesn't, since he is merely the herald of our coming nothingness, which Bergman feared at the time. Those are the last words Death speaks in the movie. Even in the penultimate scene, when he indiscriminately garners everyone in the Knight's castle, as would happen

in the plague, he is not heard or made visible. In being both present and absent in that respect, he emulates the silence that is the spiritual disease, the sickness unto death, that the Knight has been struggling with from the start and that Bergman tries to overcome in the act of faithfully portraying it.

Much earlier we had encountered another artist who makes a comparable attempt. He is the painter in the small chapel at which the Knight and his squire Jöns stop on their way back home. Being an easygoing, even jovial, craftsman who enjoys drinking with the squire, the artist cheerfully recounts the fact that there is a market for his fearful drawings. He tells Jöns that the priests will pay for painted scenes of horrific death that may frighten their parishioners into attending and supporting the church. Making a quasi-realistic film about this situation, Bergman duplicates the artfulness of the painter while also transcending it in his different medium.

He does the same with the art of dancing. When Mia and Jof, the Mary and Joseph of this allegory, do their act onstage, they show themselves to be a song-and-dance team. They sing a bawdy ditty about the crowing of the cock, which prepares us for the episode in which Skat is enticed by the blacksmith's wife, who seductively eats a chicken leg. All this contributes to a

dance of life, soon terminated for Skat but extended for the holy family whose loving-kindness toward one another prolongs their lives. At the very end the imagination of Jof reveals to him, and to us, a terminal performance that is the inversion of his and Mia's healthy skit in their little theater. It is the dance of death, put on by the string of roped prisoners whom Death has just captured. Jof tells Mia: "They are all there. The smith and Lisa [the blacksmith's wife] and the Knight and Raval [a former priest who dies miserably] and Jöns and Skat. And Death, the severe master, invites them to dance." Strictly speaking, this is not correct. Both the Knight's wife and the mute girl have been omitted from the list. But that does not matter. Of prime significance is the presentation of Death as a dance master in an art form that belongs to him uniquely. He would seem to have more vitality in him, and in the nothingness he serves, than one might have thought.

That facet of *The Seventh Seal* is parodied by Woody Allen in his version of this sequence in the final shots of *Love and Death*. Coherent with Allen's usual role as an upstage soloist, the group that Death takes off to what Jof calls "the dark lands" is now reduced to the Allen character alone. Without any prodding from Death or anyone else, the dead man jumps about in a wild and

crazy dance worthy of Groucho Marx. In its absurdity, this leaves us with a modicum of affirmative hope, parallel to what Bergman suggests in the conclusion that shows the covered wagon with the holy family inside as it moves across the broken field of mortality in which they may somehow find their future happiness together.

In Bergman's iconology, Death is not the same as the Devil. Tyan, the girl-witch, is burned at the stake because she is thought to have consorted with the Devil. She affirms as much herself and tells the Knight that the soldiers will do her no harm because the Devil abides with her. She even maintains that the Knight can find him by staring into her eyes. In a close-up of her face, the camera allows us to search for the Devil there; but neither we nor the Knight perceive anything of the sort. What we see instead, in a subsequent shot, is Death serenely pretending to be a monk as he awaits his prize. When the immolation begins, there is a look of terror that marks Tyan's realization that the Devil has abandoned her to a death that is painful despite the potion the Knight has popped into her mouth at the last moment.

This interplay between Death and the Devil recurs in the silent and dreamlike comic scenes at the beginning of *Persona*. In them a man in a nightshirt and cap

is chased across the frame, from the right to the left side
and then back again, by threatening images of Death at
one end and the Devil at the other. Being unable to es-
cape in either direction, the man finally throws himself
out the window, together with a thief and a policeman
who have also entered the little farce. At various times,
Bergman tells us, he too considered suicide as the only
solution to the necessity of his being forced to choose
between conditions in his life that were either evil or
deadly and sometimes both simultaneously.

Discussing *The Seventh Seal* as related to his other films,
Bergman characterizes its philosophical content in a
way that is especially instructive at this point. After
calling it "really close to my heart," he says that
although it is "certainly far from perfect" he finds it
"even, strong, and vital." He explains the implications
of this judgment as follows:

Since at this time I was still very much in a quandary over
religious faith, I placed my two opposing beliefs side by
side, allowing each to state its case in its own way. In this
manner, a virtual cease-fire could exist between my child-
hood piety and my newfound harsh rationalism. Thus, there
are no neurotic complications between the Knight and his
vassals.

Also, I infused the characters of Jof and Mia with something that was very important to me: the concept of the holiness of the human being. If you peel off the layers of various theologies, the holy always remains.[2]

Most intriguing in Bergman's description is the implied possibility of combining "harsh rationalism" with a perennial faith in the "holiness of the human being." In the dialectical structure of *The Seventh Seal* one may readily identify the former with the mind and behavior of Jöns the squire, and the latter with that of the Knight. As in many buddy films, and in Cervantes' *Don Quijote*, the mother of them all, the clear-sighted and debunking remarks of Jöns emanate from a rational perspective that is true to reality and unswerving in its profession of simple honesty. But it also eventuates in the sympathy that the squire feels toward those who are victimized by the terrible circumstances in which they are forced to live. Not only does Jöns save the mute girl from the rape and possible death Raval would inflict upon her, but he also takes her under his wing and gives her gainful employment as his housekeeper. He intervenes on behalf of Jof and helps him escape from the dangerous and humiliating situation he has got into at the tavern. Jöns is ready to fight the soldiers who are about to kill Tyan and restrains him-

self only because he knows it would be foolhardy to make the attempt.

Though the Knight is the one who actually gives the girl the potion that will ease her pain, that is the kind of action that the squire has been carrying out all along. Nothing else the Knight does is in any way comparable, except when he slyly distracts Death by knocking over the chessmen and so enables the holy family to make its way out of the forest. In doing this, he fulfills his mission as a Knight of Faith.

In the beginning we see the Knight wearing on his tunic a large cross that identifies the cause to which he has given himself. His prayers and everything he says are verbal expressions of the religion in which he believes. In this sad and suffering world, whose bodily delights the squire still wants to enjoy despite his sensible recognition of their deceptiveness, the Knight seeks only an answer to the puzzlement of God's silence. He wants a sign of God's existence and hidden but continued love as promulgated by the orthodox view of Christianity. But from this attitude, and from the fact that the Knight dies without receiving any response, how can his travail further any notion about the alleged holiness of the human being?

One might say that, despite his naturalistic veneer, the squire is more in touch with that than is the Knight.

Even when he successfully performs the one great act whose meaningfulness he has been seeking as the culmination of his religious dedication, the Knight does not himself entertain the possibility that this alone might be a sign of God's loving presence in the world. More obviously, one could argue, the nature of holiness reveals itself in the scene in which Jöns and the Knight partake of milk and strawberries offered to them by Mia when they jointly experience the beauty of the summer sunset on a peaceful hillside. Jof sings a song and Mia comforts the Knight in his lonely detachment from the rudimentary pleasures of ordinary existence. They have all become, at that moment, an extended community whose acceptance of one another makes them into a kind of secular congregation, as mere human beings and without the benefit of clerical supervision or traditional theology.

Mia hands out the bowl of strawberries and milk like an ad hoc priest who establishes communion with everyone who is indiscriminately present. The squire's rationalism can accommodate this, and so can his master's devotion to his sacred mission. It is a moment of epiphany that the Knight says he will cherish always. Even so, his doctrinal suppositions have sullied the basic goodness of the occasion, which Mia enacts spontaneously and without any formal convictions.

that faith in any such perfect entity created a sense of worthlessness in himself, he tells us, he became better able to make contact with other people. In comparison to the elevated ideality within theistic religions, he could only be similar to that hideous snake whose dead skin has been occupied by ants that make it look alive because they are moving in it. The supernatural dogmas of his youth had created in him feelings of guilt for doing and desiring everything that he, like other people, naturally cared about. They filled him not only with self-hatred but also with anger and aggression that he turned against his fellow humans. His fear of death, he now concluded, was a fear of augmented punishment that he would suffer after he died. In contrast to that pathological sentiment, the "situation of nonexistence" as the terminus of having lived makes him quite content. It is, for him, what he calls "a relief."

In this context, Bergman explains what he means by "the holiness of the human being" and why that idea remains after the layers of various theologies are peeled off. Once one realizes that the concern about God's existence or nonexistence is pathological, he says, one is able to see that "everybody has a sort of holiness in him." While emphasizing that no one knows its origin, Bergman affirms that it arises from human nature itself: "My feeling that God does not exist is not a terrifying

feeling. It is a feeling of security. This is the earth, we are here, and the holiness that exists—because it does exist—is inside us. It is a creation of generations and generations of hope, fear, desire, creative minds, prayers—that still exists, in me, and I am happy to have it in me.... I [therefore] try to be as good as possible ... to be a human being on the dirty earth and under the empty heaven. That is my aim."[4]

Far from being immanentistic, Bergman's faith enunciates a personal expression of what many nonreligious pluralists and naturalists in philosophy have also believed. In terms of his development as a visual and literary artist, it manifests the intellectual substance of the films that begin with *The Seventh Seal* and then lead into *Through a Glass Darkly*, *Winter Light*, and *The Silence* as well as subsequent movies that presuppose these thoughts even if they do not concentrate on them. In his mid-eighties Bergman altered some of views he had held. I discuss these changes in the epilogue to this book.

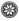

At times Bergman describes as a "trilogy" the three films I have just named. Some critics, John Simon in particular, have doubted the applicability of that term; and Bergman himself says at a later date that the

movies are not a trilogy in the ordinary sense.[5] But he also points out that there is a unifying thread that links them together. I think he is right, and that at the least they constitute a triad made between 1961 and 1963 that elaborates a coherent system of ideas about the religious problems we have been considering. All the same, they are not proffered as overt manifestations of his beliefs. They are like *The Seventh Seal* in that respect. At the same time, they differ from the earlier movie in belonging to the class of Bergman's chamber films.

Having a much smaller cast and narrative complexity than works like *Fanny and Alexander* or *The Serpent's Egg*, each of Bergman's chamber films concentrates on a particular event or situation in the lives of the few protagonists who undergo what is usually a dramatic rather than comic crisis. They are vehicles that clearly unite with Bergman's lifelong involvement in the theater, for which he wrote plays along those lines and directed dozens of the same sort that had been written by others. For various reasons, the stage can thrive with a small number of characters whose movements and involvements with one another have a direct effect upon a receptive audience. Furthermore, this simplification built into the genre allows both playwright and filmmaker to express most effectively whatever ideas or general conceptions are operative in the plot.

In retaining the thematic overtones of *The Seventh Seal* and developing them further, the three chamber films of the early 1960s differ from other small-scale movies that Bergman made in that period. *Persona, Cries and Whispers,* and *A Passion,* for instance, are not especially religious in the groundswell of their meaning. The triad or trilogy can be designated as such because each film contains circumstances—not always apparent throughout or evident at the beginning—that reflect back upon problems about faith, or the absence of it, which occur in the other two.

With few of the technical flourishes of either *The Seventh Seal* or *Persona, Through a Glass Darkly* presents itself as a somewhat anecdotal story about a family homecoming. Karin, the young wife played by Harriet Andersson, is married to a husband (Max von Sydow) who is stable, loving, and a successful member of the academic profession. Together with her teenage brother they are spending the summer in a cottage on the ocean that is owned by her parents, whose marriage has broken up. For a celebration of his birthday, her father briefly visits the group. He is a renowned author who feels guilty for having neglected his children, and to that extent he resembles the famous pianist whom Ingrid Bergman portrays in *Autumn Sonata,* itself a chamber film.

As this slightly soap-operatic plot develops, we learn that Karin has been recently hospitalized as a schizophrenic with little or no hope of being cured. She has a fixed idea about a spiritual society based on infinite love with which she communicates through the wallpaper in one of the rooms they inhabit. As a result of tensions caused by her father's visit, she becomes clinically depressed, and after an incestuous episode with her brother she has a psychotic collapse. She imagines that the God of Love worshipped by the people behind the wallpaper will now descend and take her away. What does descend, in a climax that is stunning in the intensity of its irony, is a helicopter ambulance that Karin's husband has summoned to convey her to the hospital.

The religious resonance of *Through a Glass Darkly* is suggested by the title that Bergman has given this tale. It is quoted from the Apostle Paul's assurance that though our perception of divinity remains obscure throughout our current existence, it will someday show itself with dazzling clarity. That belief may serve to assuage the agony of the Knight in *The Seventh Seal*, but it provides only cold comfort to the psychotic woman whose comparable search for God is catastrophic. The cynical squire might have devised her story, above all when she hallucinates in despair that

the God she has eagerly awaited is just a large spider—
as the helicopter becomes in her tormented imagina-
tion—that crawls into her body with ferocious hatred
rather than love.

Toward the beginning, in the playlet that Karin and
her brother have concocted as a birthday present for
their father, she has the role of a dead princess who
lures her suitor into an eternity of nothingness with
her. At the last moment he renounces this oneness
in death and chooses life instead. That becomes the
motivating theme of the movie itself. In the little play,
the princess withdraws at the end into her solitary and
loveless realm, which foreshadows what awaits Karin
in the mental asylum.

Yet the movie closes with a concluding touch that
partly resembles the hopeful ending of *The Seventh
Seal*. After their traumatic experience the father and the
son, each filled with an equally strong sense of guilt, are
finally reconciled. The son is heartened by the fact that
his father has spoken to him at last, and in a strenuous
effort to comfort the lad. For his part the father, who
was formerly contemplating suicide, feels that the
scales have now fallen from his eyes. In good Chris-
tian fashion, which is to say, in the nineteenth-century
version of Christianity, he proclaims the received mes-
sage that God is love and love is God. This notion is

indeed a form of immanentism, and it implies that by loving one another, and all of us as just the human beings that we are, we clean the darkened glass that separates us from God and so experience him directly in himself.

Some of this optimism remains in the solution that Bergman enunciates as his own, as we have seen. But almost thirty years after making this film, he spurns the father's statement. In the passage from *Images: My Life in Film* that I quoted in the first pages of this book, Bergman asserts that the sequence renders the totality of the movie "a conjurer's trick" based upon a false-hood in himself.[6] The "falsehood" to which Bergman refers consists in the making of what seems like an affir-mation of the traditional religious belief when in fact the dramatic thrust of the movie repudiates it, since Bergman was consciously articulating fundamental doubts that wracked him in those years. *Winter Light*, which appeared soon after *Through a Glass Darkly*, sharply corrects the conjurer's trick and what may or may not have been its basic deceptiveness.

One might also say that in being a step toward rectifica-tion *Winter Light* is, in another sense, a vindication of Bergman's conjuring. The screen on which he projects

his cinematic vision, like the boy at the beginning of *Persona*, itself becomes a glass through which one sees darkly. But as in Saint Paul's analogy, these words imply the existence of a reality that can in principle be revealed, or at least reflected, with creative accuracy. In that attempt *Winter Light* follows the model of its predecessor in the triad, while weaving a separate storyline tightly around the occurrence that Bergman says he heard about from a clergyman who felt guilty for the suicide of a parishioner. That was a real event, and Bergman presents it as such, but in the process he envelops it in a further cleansing of the philosophical glass through which he is seeking truth about our existence.

The original title for the movie was *The Communicants*. Taken literally, it signifies people who accept the Christian sacrament of communion. The enactment of this rite in the small congregation of the parson's church recurs in the movie. Throughout his film Bergman wants us to ask ourselves what they are communing with, or trying to. That functions as the underlying meaning of the narrative which arises out of the conditions surrounding the parishioner's suicide.

The title that survived is itself more subtle than the former one. In their thinking about the visual aspect of the films they made together, Bergman and his cinema-

tographer Nykvist always began with deliberations about the light that would appear in their photography. Bergman reports that this was a guiding and time-consuming passion in everything they did. The background lighting they chose for this story about a cold afternoon in a remote part of Sweden is inspired in two respects. By uniting the gray and somber sky with the dismal look of the terrain beneath, it more or less erases our normal perception of the horizon. This avoidance of any suggestion of a metaphysical dualism serves as a background to the dreadful loneliness and basic isolation of the communicants, both in the church and in their society outside. But it also prepares us for the preacher's ultimate, and depressing, oneness with his flock at a time when he has painfully reached a point of utter despair about the spiritual darkness in which he lives.

Since its cast includes the varied individuals who belong to the congregation, *Winter Light* is less of a chamber film than *Through a Glass Darkly*. Or rather, it is a chamber work that is scored for a small orchestra rather than a quartet. At the same time, it deals largely with the relationship between the preacher and the woman he loves, in some sense or other, and would marry if he were not so greatly troubled in his soul. Like Bergman as he was in the depths of his religious

quandary, the priest is engulfed by a search for signs of God's love, or even existence, which is comparable to the Knight's quest in *The Seventh Seal*. But more than the Knight, and closer to the condition of Bergman himself in the intervening years, he has almost completely lost his Christian faith. His feeling that life is therefore not worth living is augmented by his sense of cowardice and duplicity in remaining a clergyman. The woman who loves him plays a part in this that resembles the squire's in *The Seventh Seal*. Like him she has no religious faith. She is nevertheless unflagging in her attempt to help the priest. Even after he tells her he is incapable of love for anyone, including her, she stands by him as a counterfoil to his enduring agony.

The interweaving of these strands culminates in the brief and exquisitely restrained scene that ends the movie. We see the preacher, played by Gunnar Björnstrand, drained of energy both spiritual and physical, giving communion as he has done before. Nothing has changed for the better. He has not received a sign from the God he hardly believes in any longer; he finds this silence more unbearable than ever; he still feels guilty for the death of the parishioner who came looking in vain for help with his urgent problem; he has strenuously rejected the marital and genuine love that has been offered him; and he continues to suffer from

the psychosomatic flu that he has had thoughout the movie.

In the face of all this, and with an august though pitiable manner enacted to perfection by Björnstrand, the priest stoically administers to his flock. The contact with these people, if not indicative of any transcendental unity that might have brought them together under his stewardship, somehow contains a suggestion of its own holiness. As yet, however, the meaning of that could not be further clarified by either Bergman or the priest.

Though it reaches no definitive solution to the religious questions that Bergman studies in these works, *Winter Light* is supremely successful as an expression of the ambiguities in life that are always present in his films. At the same time, it enunciates an acceptable and sustaining principle. Bergman later explains what that moral is by reference to something that happened when his father forcefully intervened, in a church that he was visiting, and managed to prevent the cancellation of a service. As Bergman says: "Thus I was given the end of *Winter Light* and the codification of a rule I have always followed and was to follow from then on: *irrespective of everything, you will hold your communion.*"[7]

Moreover, the harmonic structure of the film's progression has a rhythm that Bergman correctly ascribes

to the music of Bach and other composers he admired. The close-ups to which he often resorts in this inwardly oriented movie are like notes and chords that move surely and relentlessly toward their ordained completion. I think that is what Bergman meant when he likened film and music: "Both affect our emotions directly, not via the intellect, and film is mainly rhythm; it is inhalation and exhalation in continuous sequence."[8]

Looking back, many years afterward, at the achievement of *Winter Light*, Bergman states that once he had made this film "that enormous, neurotic fear of death that you see in *The Seventh Seal* was completely wiped away" and he could henceforth accept himself as well as life in general as it is. He also remarks that *Winter Light* was the last film in which the question of God was present either directly or indirectly.[9]

Since *Fanny and Alexander* had appeared shortly before Bergman made this assertion, one could possibly question its accuracy. He might answer that neither the doctrinaire cruelty of the stepfather nor the hoax about God's appearance in Jacobi's apartment is really relevant to the all-inclusive longing for God that dominated films like *Winter Light*. That could be a satisfactory reply, but we would still have to account for the sense in which *The Silence*, made the very next year, can rightly

be experienced as a sequel to both *Through a Glass Darkly* and *Winter Light.*

In a most obvious manner, *The Silence* deals with modern civilization as a place in which the silence of God has been thoroughly accepted as an established reality in our life. The search for a word or other sign of his existence no longer occurs in the fictional conditions that Bergman depicts as the setting for the movie. Nothing like the suffering of the Knight in *The Seventh Seal* takes place in this not-so-brave new world. The concept of silence enters into Bergman's thinking in different ways that I will discuss. What is pertinent as a prior condition in *The Silence* is the absence of any sound, or even noise, that could make life meaningful after one has got beyond "that strange thing I called 'God,'" as Bergman described the object of his earlier preoccupation.[10] This thread alone links *The Silence* to the two other movies in the triad.

Bergman's thinking about some future no-man's-land, in which the problematics of Judeo-Christianity have been totally discarded, pervades a succession of engrossing scenes. They are more vivid and well-constructed than those that clamor for attention in some of his other movies. The unreal, or what could be

called uncanny, aura of the narrative resembles the prevailing mood of *The Serpent's Egg*, the big-budget and Hollywood-type production that Bergman made fourteen years later and then condemned as "not a very good picture."[11] As in *The Silence*, *The Serpent's Egg* deals with characters who are unable to face up to the nothingness of their lives as imposed upon them by contemporary society. Bergman traced the failure of *The Serpent's Egg* to his decision to locate the plot in Berlin during the 1920s. What he ended up with, he says, was "a Berlin that nobody recognized, not even I." He shrewdly observed: "If I had created the city of my dreams, a city that does not exist and never has... I would have brought the audience with me into an alien but secretly familiar world."[12]

That is what he did do in *The Silence*. It is the portrayal not only of a dream world but also of something we recognize as a nightmare, gripping and disturbing but too beautifully conceived for us merely to recoil in terror or wish to be awakened from this aesthetic presentation of its lurking fearfulness. In that regard *The Silence* is a masterpiece in a class with Antonioni's *L'Avventura* and Welles's *The Trial*, all three made within two years of each other.

The noiseless nothingness of *The Silence* begins in the long first sequence on the train. Except for occa-

sional reminders of the sounds that passengers would naturally hear about them, the lapses in the soundtrack cause us to concentrate on the visual images while the intermittent recurrence of this circumvening silence makes us wonder what region of the imagination we as well as the characters are traveling through. It is an effect that Cocteau could well have used in *Orphée*, if he had chosen, for his depictions of "the zone" in which the dead enact their arcane vestiges of life.

The three protagonists in *The Silence*, voyagers in its wasteland deprived of even the horrifying emotion of not finding a God one desperately wants to believe in, are the two sisters, Ester and Anna, together with Anna's prepubescent son Johan. The train takes them north toward their home in Sweden through a land that might be one of the Baltic States. They stop to spend the night in a city that is unknown to them, and for which Bergman invents the name Timoka. In Estonian the word means "the hangman." Its native language they do not speak. They stay in a sumptuous hotel that has few other guests at the time. Though its baroque appurtenances are obtrusively ornate, the abode seems ghostlike. The hushed movements of the servants in its silent atmosphere renew the bleakness of the train ride. The two sisters are different types of people: Karin intellectual and distanced, Anna erotic

and alive but distorted by her hatred of Karin and her interpersonal failures with men. At the end Anna liberates herself from Karin, who is mortally ill and cannot leave the city with her and Johan.

Against the ghoulish background of Anna's self-destructive searching for and final discovery of humiliating sex, Ester's compulsive autoeroticism, the unresolved bitterness between the two sisters, and the frozen loneliness of the well-appointed but deadly hotel, some vestiges of true vitality emerge. One consists in the presence in the hotel of a troupe of performing dwarfs, whom we see in one of their comic skits on stage as well as in their preparations in their room at the hotel. They befriend Johan as a fellow outcast from respectable society whose imaginative curiosity they understand and appreciate. Another of these meager but valid roots of life is the old waiter who carries into Ester's room the radio that plays Bach's music, which somewhat penetrates the silence and the suffering of the sick woman. But most of all, it is Johan himself who projects the questing growth of the human spirit.

From the very first shots of *The Silence* to the last, which circle back to a homeward bound train, without Ester onboard this time, Johan's healthy inquisitiveness and unrelenting hunger for meaning in life bind together almost everything we see on-screen. Even the

unhappy sexual acts of his mother and his aunt are shown to us within the context of Johan's desire to understand what their behavior signifies. One commentator says that "the sisters' craving for emotional warmth is filmed in a cold, objective style."[13] This is correct, but only in the sense that in his usual manner Bergman counterpoints his depiction of devastating nothingness with an exquisite realism that asserts the truthfulness of what he is showing us. Beyond all that, or rather throughout it, the style is not at all cold or objective. The experience of the boy creates the ardent and subjective perspective from which Bergman has constructed the entire work.

In one of his interviews, Bergman avows that he is like others who return in thought to their childhood experiences as they get older. But—as I mentioned previously—he says that the situation is special in his case because he has always been living with those memories and they appear in everything he does as an artist. With this as a clue, we can discern the identity between Johan and the boy, a little older but of a similar age, who traces on the screen the inspiration for what he will create as *Persona* once he becomes Ingmar Bergman the mature filmmaker. Johan's similarity to the Alexander of *Fanny and Alexander* is also evident. The élan vital that flourishes in them provides the

balancing element that Renoir tells us he introduced as a kind of prop to keep some narrative development steady.

In Bergman's vision, above all in *The Silence*, it is the receptive though alert and vibrant awareness of the boy that equilibrates the oddness and inscrutability of the world in which he must somehow learn to live. In a corridor of the hotel there is a large reproduction of a Rubens painting of a lascivious satyr who tries to grasp the leg of a voluptuous nude. We see it twice and the boy seems to study it casually for a moment. It reminds us of his mother's sexual exploits, but more essentially it is a scene in which merely physical sexuality excludes any further meaningfulness. Johan's irrepressible imagination counteracts the negativity in that.

If this is true, then we have additional reason to view *The Silence* has having a place in the triad to which *Winter Light* and *Through a Glass Darkly* also belong. The holiness in human beings, in sheer humanity as a peculiar product of nature at large, survives and becomes a saving remnant even in the nightmare that is life permanently devoid of hope that any divinity will ever make an encouraging sound—unless this sound is in the music of Bach or some other great composer. And there too a silence resides, but one that remains reverential to what is good and beautiful in our experience.

Bergman's faith in this aesthetic potentiality shows itself again and again.

After he had worked his way through the puzzlement about God's silence, Bergman seems to have acquired the ability to cherish the silence that surrounds us in the natural environment. He perceived it as a type of reality that modern conditions have readily destroyed in the name of progress, which mainly generates the noisiness of industrial development as well as competitive greed and the hazards of overpopulation. Bergman retreated to the remoteness of Fårö with the intention of finding a cleansing silence in everyday life at its best. The characters in several of his movies make reference to this. The Stockholm Archipelago often served as his idyllic location, but Fårö itself also became a meaningful setting for narrative productions as well as three documentaries about it.

Wittgenstein wrote, "Wovon man nicht sprechen kann, darüber muss man schweigen" (Whereof one cannot speak, thereof one must be silent). He was referring to the innate ineffability that resides within all human experience. John Cage made silence as prominent a mode of musical expression as the sounds composers organize in the traditional manner. In Bergman's movies the frightening prospect of living without a fortifying sound from on high is transmuted into an

opportunity for mankind to cultivate and to relish on earth the silence announced by the line in the Book of Revelation that is read by the Knight's wife: "And when the Lamb broke the seventh seal, there was silence in heaven for about the space of half an hour."

Bergman understood the nature of that overwhelming silence as well as anyone has, and he frequently evoked it within his medium. The second of the three trials in *The Magic Flute* that Tamino must endure is the trial of silence. He passes it and appreciates its importance. Neither Pamina nor Papageno can do so, and they each try to commit suicide. The simple faith in love pronounced by both of them is not enough.

In *After the Rehearsal* Bergman's semi-autobiographical theater director (played by Erland Josephson, himself a director) tells the young actress: "Listen to the silence [of the stage]. Imagine all the mental energy, all the feelings, the laughter and rage and passions. It is all still here, shut in, living its secret, continuous life." According to a journalist's report, when Bergman was directing Ibsen's *Peer Gynt* in Malmö, "he loved silence so much that he had a board erected, with the words *shut up!* written on it in ninety-seven different languages!"[14]

In the decades that followed *The Silence*, Bergman's films are permeated by his investigation into the possibility of finding salvation through contact with other human beings, each inherently worthy of respect apart from any transcendental God. The audience of attentive faces during the *Magic Flute* overture is assembled the way it is to demonstrate the diversity in humankind as manifested by the different though equally commonplace appearance of these individuals. Bunched together in silence on their wooden chairs, they look less like aficionados at the opera than like members of a convention or reunion sitting before the photographer's commemorative camera. I am always aware of Bergman himself arranging, if not commanding, the universality of their frontal gaze. I also sense his presence in the opera itself when the characters sing about love as the meaning of life. While doing that, they hold placards on which are written their words of affirmation about the goodness of *human* love. For me these cards convey the message of the sponsor, who in the film is Bergman as well as Mozart and Schikaneder.

Bergman's sustaining and humanistic guidance is felt differently in other films. Given his confessed adherence to his own personal experience, the aspects of his complex being express themselves with varied and highly modulated inventiveness. In *The Magic Flute*

he alters the original text by turning priestly Sarastro into a loving father of Pamina, thus changing Mozart's Masonic mysticism into an account of family administration being wisely handed down to a worthy son (or rather son-in-law, in the case of Tamino). The values and potential goodness of the family, both one's own and the family of mankind, are more thoroughly explored in *Fanny and Alexander*. But before getting to that, we must remember that many of the films Bergman made in the 1960s and the 1970s manifest dark nights of the soul as he struggled to find his post-theistic path. Despite the brilliance of movies such as *Persona, Shame, A Passion* (usually and misleadingly called *The Passion of Anna*), *The Hour of the Wolf*, and *Cries and Whispers*, they are all horror stories about human isolation and the excruciating perils that even humane and talented people face in struggling to overcome it.

If these are powerful films that can haunt us with the sense of how hard it is to be a loving person, their strength arises from Bergman's technical insight and cinematographic expertise that seduce us into, and through, the painful situations he portrays. As against the criticism he received, Bergman said that *A Passion* is one of his pictures that he liked most, partly because of the six-minute close-up monologue of the Liv

Ullmann character talking about her marriage. "It's just running," he remarks. "The camera doesn't move. That is, to me, the most *alive* moment in my whole career."[15] Bergman claims that without being realistic or obvious, this long sequence is so well acted that it tells us everything the personage says is a lie. How people lie to themselves, and therefore lie to others, about their intimate feelings and relationships is the theme of all the films Bergman made in this period. It is a condition that seems to derive from the sense of alienation as well as the humiliation that men and women experience once they realize they are cut off from other human beings and from the community they would like to share with them. Whether or how much Bergman himself endured the pathology of this condition is of secondary interest. What matters most is his ability to formulate it with ever-increasing virtuousity through the cinematic contrivances under his control.

As an example of that in relation to *A Passion*, consider the final moments of the film. Anders, the intellectual outcast and typical Bergmanian rebel, has been living alone. He has an incomplete affair with the Bibi Andersson character, and a more extended live-in relationship with Anna (Liv Ullmann), whose marriage had been destroyed when her husband and child were killed in an automobile accident. After a number of

harrowing events in the neighborhood that have unnerved Anders beyond his capacity to cope with them, his latent hostility toward Anna makes him feel that he cannot bear any longer either her society or any other society. As she is driving the two of them in her car, he berates her as someone who has repeatedly lied about the goodness of her marriage and therefore is a person he cannot trust.

The isolation of these two individuals, and their inability to love, is the burden of the film. On this fairly trite note it has to finish. But there are at least two ways to end. In the novelette that Bergman wrote as his equivalent of a screenplay, Anders narrates how Anna goes insane as she listens to what he says to her in the car. She somehow crashes it and dies in the fiery explosion that results. Anders is thrown into the road, close to where the other woman lives. As he passes out, he keeps repeating the closing words: "Forgive me. Forgive me. Forgive me!"

This overly melodramatic termination is completely absent in the film. There is no crash and no explosion. Instead, Anders gets out of the auto in his confused state of mind and Anna resolutely drives off. One assumes that she knows that nothing more is possible in her relations with Anders. The camera then shows him as he stands alone on the country road in a flat

and dismal landscape. He is seen at first in a very long shot, initially walking in the direction of Anna's car but then back again, and then back and forth slowly and in great consternation. The camera gently zooms in, closer and closer to him. As this happens, the colors and the figures, including his, become more and more indistinct. We are left with the idea that his personality is dissolving before our eyes. It is this kind of directorial astuteness that makes the movie not only intriguing but also quite effective in its mythological intent.

In his brief mention of *A Passion*, Bergman says that it is "related to the Passion of St. Matthew, or something like that."[16] He is probably referring to the Bach oratorio *St. Matthew's Passion*. But he does not indicate in what sense this kind of Passion is related to his film. In the movie itself we see little evidence of any emotional attraction, whether sexual or otherwise, that might attach a man and a woman to each other— Anders and Anna, in particular. Passion in that sense seems to be ruled out from the start. The two protagonists need one another without being able to feel ardent bonding with each other. The intimacy they mutually experience is therefore an accretion of suffering that eventually convinces them that they cannot and should not remain together. Since the film is presented from the man's point of view in almost every frame, and

that man is an exceptional loner, one might plausibly identify his condition in life with the agony of Christ. At the same time it is notable that Anders's modern-day Passion is not bolstered or even affected by any overarching mission. On the contrary, he has been chosen, by Bergman, to represent the latent misery that all men of his sort must face on their own.

In other films of this period, Bergman employs a similar conception, though altered in its narrative details. In *The Hour of the Wolf* the outsider (played by Max von Sydow, who also played Anders in *A Passion*) shows himself capable of not only harsh aggressiveness but also the psychopathic murder of a boy who has been bothering him. Whether the murder we see on-screen really happens, or is only a dream or fantasy, remains unknowable in the story as it develops.

In this film, as in the others like it, and above all in *Persona*, as we will see, Bergman freely introduces shots that defeat any literal realism in order to suggest possible or smoldering feelings that are true to some affective situation without becoming overt in a character's behavior. Far from undermining Bergman's realistic portraits of human hostility and hatefulness, these devices support them through his artful reliance upon effects that are appropriate and thoroughly filmic. As Bergman says in an interview: "Film as a medium is well suited

to destructive acts, acts of violence. It is one of the cinema's perfectly legitimate functions: to ritualize violence."[17]

In *Shame* the ritualization has been changed to a background of brutal civil war that evokes from the von Sydow character (in this film, a sensitive violinist) his willingness to kill anyone who might conceivably threaten his desire to escape annihilation. In *Persona* and *Cries and Whispers* the point of view zeroes in on women who suffer in circumstances that preclude their attaining the interhuman love that they crave without any real hope of attaining it. These variations on the Bergman theme are extensions, elaborations, of the perspective in *The Silence*. They are further phases of his analysis of metaphysical anguish, which continue as late as *Face to Face*, *The Serpent's Egg*, and *From the Life of the Marionettes*. The depressiveness of all these films belongs to an ambivalent dialectic in relation to the more optimistic and benign approach of *The Magic Flute*, *Fanny and Alexander*, and both *Scenes from a Marriage* and *Saraband* in their final segments.

In *Scenes from a Marriage*, the suffering of the female serves a beneficial function because through it Marianne (Liv Ullmann) is able to achieve self-awareness and a degree of self-reliance that she would not have had otherwise. In *Persona* the actress embodies the silence

in herself: she becomes silent as a reaction against the nullifying meaninglessness of her professional life. She too is played by Liv Ullmann, who also portrays one of the throttled sisters in *Cries and Whispers*.

In *Shame* and *A Passion* Ullmann enacts a woman who suffers because of the man's insurmountable suffering. But in *Scenes from a Marriage* her character reaches a level of authenticity that reveals how women in and out of love can grow as human beings despite their miseries. Marianne finally attains an independent voice that transcends the traditional female silence in a male-dominated world, as well as any silence in the universe as a whole, to which women—like everyone else—are inevitably subjected. To understand this positive strand in Bergman's tapestry, I turn to the history of his thinking about love and sexuality.

Though it may seem anticlimactic, I begin this part of our discussion with the last words in Bergman's five-hour television version of *Scenes from a Marriage*. Marianne and her first husband, Johan, are long since divorced and resettled in marriages to others, marriages that are not only unsatisfying for each but also without meaning. They come together in a secretive sexual rendezvous in a friend's vacant cottage in the country.

After they make love, they go to sleep together and Marianne awakens in agitation from a nightmare. She turns to Johan for consolation in his arms. Sitting up in bed, she tells him of her terrifying dream, in which she has lost her hands and with the remaining stumps cannot hold on to him or their daughters. The ending of the film is as follows:

Marianne: Johan?
Johan: Yes, my dear.
Marianne: Are we living in utter confusion?
Johan: You and I?
Marianne: No, all of us.
Johan: What do you mean?
Marianne: I'm talking about fear, uncertainty and ignorance. Do you think that secretly we're afraid we're slipping downhill and don't know what to do?
Johan: Yes, I think so.
Marianne: Is it too late?
Johan: Yes. But we shouldn't say things like that. Only think them.
Marianne: Johan, have we missed something important?
Johan: All of us?
Marianne: No, you and I.
Johan: What would that be?
Marianne: At times I can read your mind, and I feel such tenderness that I forget myself. Without having to efface myself. It's a new sensation. Do you understand?

Johan: I understand.

Marianne: Johan, sometimes it grieves me that I've never loved anyone. I don't think I've ever been loved either. That distresses me.

Johan: Now you're being overly dramatic.

Marianne: Am I?

Johan: I know what I feel. I love you in my selfish way. And I think you love me in your fussy, pestering way. We love each other in an earthy and imperfect way. But you're so demanding.

Marianne: I am.

Johan: But here I am, in the middle of the night, without much fanfare, in a dark house somewhere in the world, sitting with my arms around you. And your arms around me. I don't have a great deal of fellow feeling.

Marianne: No, you don't.

Johan: I don't seem to have the imagination for it.

Marianne: No, you're rather unimaginative.

Johan: I don't know what my love looks like, and I can't describe it. Most of the time I can't feel it.

Marianne: And you really think I love you too?

Johan: Yes, I do. But if we harp on it, our love will evaporate.

Marianne: Let's sit like this all night.

Johan: Oh, no, let's not.

Marianne: No?

Johan: One leg's gone to sleep, my left arm's practically dislocated, and I'm sleepy, and my back's cold.

Marianne: Then let's snuggle down under the covers.

Johan: Yes, let's.

Marianne: Good night, my darling. It was good talking to you.
Johan: Sleep well.
Marianne: Thanks. Same to you.[18]

With this as a consummate, but previously unattainable, summit of his thought toward which Bergman had been striving all his life, we can trace some of the highlights in other films about love he directed and usually wrote. Several of his earliest movies lay a foundation for his later great ones.

Summer with Monika is a good place to begin. The title is misleading, with its intimation of an adolescent fantasy about a time of freedom and abandon in the company of a desirable woman. Actually, that description is pertinent for the events at the beginning of the movie. But in the course of the narrative, and above all in its climax, the film becomes a case history that reinforces the cynical assumption that sexual exuberance on the part of the teenage lovers can only lead to disaster. Monika and her boyfriend Harry try to escape their proletarian oppression by stealing his father's motorboat and taking a lengthy holiday, camping out in the Stockholm Archipelago. When she gets pregnant, they marry in an ebullient atmosphere of certitude about their oneness and with high expectations for their future together. As they return to the squalid reality

of their existence, however, they fall apart and Harry eventually takes their baby to a state institution.

Filmed with pointed contrast between the beauty of nature in which the original love arose and the ugliness of the marital burdens to which it leads, the movie is sensitively balanced in its sympathy for both Monika and Harry. Toward the end of the film, at a moment when her waywardness shows her at her most repugnant, Monika looks into the camera as if to seek emotional support from the audience. Later weak and inefficacious Harry peers at us in a similar attempt to get our understanding of his plight in being married to someone like Monika. Having observed little or none of the sexual joy they must have felt at the beginning, we glean that there is hardly anything in their relationship to gainsay the misfortune of their marriage. In the final shots as Harry all alone takes the baby to the orphanage our heart goes out to him, an innocent father who has been forced to give up his little girl. Yet the sadness of Monika also lingers with us, and we must put the blame on the heartless society that managed to destroy these youngsters.

Though Bergman has said that he knew little of Renoir's cinematic work, *Summer with Monika* could very well have been influenced by the realistic gems that Renoir made in the early 1930s. On Bergman's

comic side, *A Lesson in Love* has all the wit and madcap abandon of the American movies that were also being made in the 1930s. Like *The Awful Truth*, featuring Cary Grant and Irene Dunne, *A Lesson in Love* deals with the postmarital skirmishes of a separated couple who do not recognize at first how deep their love for each other really goes. The film concludes with a kind of wild disruption in society—riotlike conditions in a Stockholm nightclub or disreputable bar where, until the police arrive, young men and women have been disporting in the frantic dance steps of the time. Gunnar Björnstrand and Eva Dahlbeck star as the married couple trying to rediscover their love for each other as if they were rehearsing for their sequel the following year in *Smiles of a Summer Night*. By then, the comparable characters have become older and wiser in the distressing uncertainties of love and sexuality.

Bergman's sense of ambiguity is evident in all the movies he made during his initial efforts in the 1940s and early 1950s. Some of these films are sentimental and others neorealistic in the fashion that moviegoers had learned to appreciate. Most of them seem commercially oriented, motivated by concern about success at the box office. After the financial and critical triumph of *Smiles of a Summer Night*, Bergman availed himself of his consequent freedom by writing and directing the

great films that express his outlook on the world as a creative artist devoted primarily to the conceptual possibilities of his craft. The neorealism remained as a foundation for the personal reflecting of reality that conveyed his own thought and personality. The experimentation that had been severely restrained before became more inventive, and the mythic layers of his perspective took on a thematic importance they formerly lacked. In relation to myths of love and marriage, Bergman's residual ambivalence could now assert itself with an overt tenacity that served as the hallmark of his work.

Like *A Summer with Monica*, the other early films often present the sensuous and consummatory basis of interpersonal love as the vitality that lures a young couple into some undesirable marriage that ultimately becomes ruinous. Nevertheless, it is only in *The Devil's Eye* that Bergman explicitly reveals the approach to sexuality that recurs in all his subsequent productions. That film, subtitled *A Rondo Capriccioso*, is usually considered to be a minor divertissement, and a surprising one since Bergman made it in 1960, a year after *The Virgin Spring* and a year before *Through a Glass Darkly*. In later interviews he dismissed all three as inauthentic efforts on his part, the last two as dishonest in view of his religious disbelief, and *The Devil's Eye* as trivial or

pointless. Some critics have suggested that the latter is of interest only because it expresses Bergman's adoration of Mozart operas, in this case *Don Giovanni*. As a matter of fact, however, his anecdotal rondo resembles the Mozart masterpiece only in presupposing our acquaintance with the Don Juan myth.

In *The Devil's Eye* the accompanying music on the harpsichord is a piece by Domenico Scarlatti that could have been used for a comedy of manners by Marivaux in the eighteenth century. But even at the time that Molière—whom Bergman idolized—availed himself of the Don Juan legend, that myth was often considered old hat and likely to bore a contemporary audience. Bergman deals with this problem by picking up the story after its traditional ending. Don Juan has been dragged down to hell, where for the last three hundred years he has undergone daily punishment for his sinfulness. In his luxurious bed he is awakened each morning by a beautiful woman who seduces him into making physical love to her. He reluctantly does so each time but then, when his hormonal drive has been aroused, he is abruptly interrupted. The woman vanishes and he is chastened by the frustration he feels.

After centuries of such torture all erotic impulse has been drained from this Don Juan. From start to finish in the movie he retains the polish and sophistication of an

accomplished member of the upper class who knows how to simulate love but cannot experience it himself. He has none of the lively sexual excitement, whether sensuous or passionate, that Don Juan displays not only in Mozart's and Molière's versions of the myth but also in those of Byron, Kierkegaard, and hundreds of others in the modern world.

In *Man and Superman*, Shaw's lengthy dream sequence, sometimes excised from the play and performed separately as "Don Juan in Hell," also centers about a world-weary and nonerotic bearer of the myth about masculine sexuality. Shaw's Don Juan engages the Devil in philosophical discussions in which he proves himself to be mentally superior and motivated by an almost Platonic love of abstract reasoning. As a hero of that breed, he turns away from the instinctive pleasures the Devil offers him and to which hell devotes itself as a kind of postmortem earthly paradise. At the end of the Shavian dream, Don Juan ventures forth to the heaven in which elective souls like him devote themselves to metaphysical speculation.

In Bergman's reaction against his religious origins, he entertains no conception of this sort. His Don Juan is not a man of ideas, and he intrigues us less because he has lost his natural virility than because he is so totally blasé about his deprivation. He is by now largely

passive in the human circumstances that hover about relations between men and women. Though Bergman had directed an innovative stage production of Molière's play called *Dom Juan*, the protagonist in his film (adapted from a Danish radio play) in no way resembles the young and exciting intellectual that Molière projected.

In the movie the Devil offers Don Juan a shortening of his sentence in hell if he returns to earth and has sex with an innocent and virginal girl, a parson's daughter who is engaged to a young man she truly loves. With his virtuosity in the mechanics of seduction, Don Juan accepts the challenge. He then succeeds. But he is virtually a supernumerary in the plot. Its dramatic import consists in the emotional florescence of the young girl and her mother. After much banter and evasion, the latter succumbs to the blandishments of Don Juan's servant. In this version the servant is named Pablo rather than Leporello as in Mozart or Sganarelle in Molière or Catalinón in Tirso de Molina, the originator of the legend.

Pablo differs from these other compliant servants in being a Don Juan himself, not just in existing as an ordinary man who wants to emulate the master (which they do too) but also because he is himself a masterful practitioner of the same type. He is even better than

Don Juan as a representation of the frank and carnal animality that Bergman had already sketched in likable characters such as the coachman Frid in *Smiles of a Summer Night* and less appealing ones such as the actor Skat in *The Seventh Seal*.

Though Don Juan is transported from the realm of the dead to the land of the living, he remains throughout this film a nobleman who is shallow and morose (as are all the other aristocrats in Bergman's movies). He is in fact a figment of death-in-life. Scarlatti's vivacious Sonata in E Major, heard during the credits at the beginning, leads us to expect a Don Juan who would be bursting with liveliness, sparkling in his erotic presence. He turns out to be entirely deficient in that regard, and only Pablo strikes us as a real man still actively endowed with the appetites and inclinations that most human beings have innately and enjoyably. Furthermore, Pablo is sensitive, sympathetic toward women, and wholly cognizant of their virtues and special situation in life.

The Devil had ordained that Pablo could travel to earth with Don Juan only on the condition that he would avoid all carnal temptations and any impulse to seduce a female. The rationale for this we never learn, and anyhow Pablo disregards the injunction. While knowing that he risks severe punishment for violating

the Devil's order, Pablo succeeds in having sexual intercourse with the parson's wife, the mother of Don Juan's victim. She opens herself to the pleasures that her loving but distracted husband has neglected in his devotion to his religious calling. Like her daughter, the wife finally welcomes the obvious goodness of consummatory lovemaking. They repel the guests who have entered the household until these men, whose sincerity they have good reason to doubt, are able to elicit a strong maternal impulse in each of them separately. The women respond to the pathetic state of the suppliant males who throw themselves at their feet like infants in need of bodily comforting. The scheming of the men wins out because they are so greatly driven by their physiology to search for gratifications that in themselves are relatively unimportant.

This mode of depicting intimate relations between men and women, and in the context of a mythological fable about the effort of males to overcome the resistance of females whose love they wish to capture, recurs throughout the Bergman canon. In *Secrets of Women* and *A Lesson in Love* (though also in the hard-hitting *Prison*), the women remain with their damaged mates for reasons that are more maternal than amatory. The men are generally motivated by preconceptions they interpret as biological imperatives. Their resultant

weakness and anxiety, even depression and episodic madness, make them wretched until one or another woman takes charge and tries to pull them out of their self-imposed morass. With women who are properly emancipated, the tactic works occasionally.

In Bergman's early and middle films, as exemplified by *Dreams* and *The Touch*, the realistic dramas normally result in disillusioned failure for the women as well as the men. The comedies sometimes culminate in a transition from the embattled courtship we have been watching to a marriage that may possibly be harmonious in the future but that we must blithely imagine on our own. By the time Bergman gets to *Scenes from a Marriage* and then *Fanny and Alexander*, he changes his treatment of these mythological themes about sex, love, and marriage. He digs deeper into their implications and suggests solutions that may, partially at least, make life worth living.

In *Smiles of a Summer Night*, as in *The Devil's Eye*, Bergman's imagination focuses most attentively upon the ability of remarkable women to micromanage one or another benign resolution that the males can hardly effect by themselves or even comprehend. One may wonder why these women would have found the men

desirable, but possible reasons are intimated in each case. The wife in *A Lesson in Love* has left her husband the gynecologist to become the mistress of a bohemian painter for whom she had previously been a model, but she herself is much more bourgeois than bohemian. Though the famous actress in *Smiles of a Summer Night* knows that former lover Egerman is a dull lawyer foolishly married to a young girl more suitable for his son than for him, she has been raising a son all alone and feels a need to settle into a more stable lifestyle. Nevertheless what comes to the fore is the power to love that the women have, and that the men need to acquire through them.

In *The Devil's Eye* this theme is partly sketched but then terminated indecisively. While the heroes of the piece are the two women, we know in advance that they cannot go on to marry Don Juan and his servant Pablo after the three hundred years these celebrated individuals have been mouldering in hell. What matters instead is the moral triumph that results from their freely chosen decision to have extramarital sex with men they do not love. The mother's behavior leads to an augmenting of the love she and her husband share once she tells him what she has done. From her experience he learns what he needs to know in order to become a better and more satisfying husband. For her

part, the daughter tells Don Juan that, without loving him, she wants to alleviate the pain that emanates from his limitations and toward which she feels compassionate. In the arms of the young man she does love and is shortly to marry, she lies about the coital relationship she has had. This is enough for the Devil's purposes, and it yields Don Juan his reward when he goes back to hell. Neither he nor the Devil is capable of understanding the moral and spiritual force that the so-called erring women attain in their circuitous search for a marriage that can have greatest meaning in their life. The female protagonists that appear in *Fanny and Alexander* and *Scenes from a Marriage* are more advanced specimens that evolved out of them.

What Bergman had in mind as happy and commendable love between men and women who live in harmony with nature was already foreshadowed by *Summer Interlude*, a major film he made as early as 1951. Though the ballerina who reminisces about her summer of erotic excitement when she was fifteen has been depressed ever since, she recovers her stamina to some extent after the rehearsals are over and she has her performance onstage. The death of the boy she loved had dragged her down during the thirteen years

that followed it, and her current attachment to a man of her own age is fraught with interpersonal difficulties. But she shoulders on at the end as both a performing artist and a woman who remembers what real love can be like. By devoting an almost equal portion of the film to both the adolescent romance and the disillusioned state of the ballerina in the present, Bergman clearly establishes his later ambiguity about love as either authentic and natural or else idealistic and therefore liable to self-delusion. The possibilities of harmonizing the two in a durable relationship is only briefly intimated in the final moments of the movie, but anything more would have been too heavy for the delicate plot.

Summer Interlude is also interesting because it includes specific themes that reappear more fully envisaged in later Bergman films. For instance, the boy that the young ballerina loves is living in his aunt's house on the ocean, and we see the elderly woman, in her one scene, playing chess with the local priest. She is dying of cancer, and her face is sickly and whitish. She claims that she has learned how to live with her terminal condition and that others will meet their death before she does. Since the clergyman has just made a move to checkmate her on the chessboard, we assume that she is deluded about the timing of her demise. But then the boy dives into the ocean soon afterward,

accidentally hits a ledge in the water, and dies from the concussion. Before that happens, the priest remarks to the ballerina that he plays chess with the old lady for a quasi-professional reason: it puts him in contact with death.

Leading our imagination this way to the fatal event that is central in the narrative about the ballerina's affective crisis, Bergman might be said to have avoided any overt symbols, as he repeatedly asserted. But what about the screeching of the owl that had made the girl apprehensive despite the ecstatic love she feels, and then the sudden close-up of a dark cloud that fills our view of the sky? These are overt symbols, and rather clumsy ones. By the time Bergman returned to images of Death playing chess in *The Seventh Seal*, he had acquired the skill to integrate meaning into the linear plot without using such merely symbolic overlays.

In one scene in *Summer Interlude*, however, his purely cinematic preparation for something that comes later is done with brilliant audacity. Drawing figures on a pad to amuse her lover, the young girl playfully makes caricatures of the old aunt, the priest, and the death they had been discussing. Gradually but then totally, her drawings turn into animated cartoons that spritely move about on the page as they would on a movie screen. As opposed to ordinary doodling on

a pad, this is thoroughly unreal, of course. But it's done with such humor and aplomb that we gladly accept it into our experience of the otherwise realistic film. Greatly magnified in importance, as I've suggested, this magical effect recurs in *Prison, Persona, The Hour of the Wolf,* and other Bergman movies that command our attention by means of their aesthetic unreality. Throughout the films of the 1960s and 1970s, Bergman relies more and more upon cinema's capacity to shock and provoke any audience that can submit to the stimulating but often unpleasant feelings that it may produce.

3

Ambiguities of the Human Condition

To explain Ingmar Bergman's development during his later period, we do best to return to *Persona*. It is a fountainhead from which the two streams of his ambiguity about the human condition issue forth. The dynamic core of the film resides in the concept of merging, and its manifestation in the fusion of the faces of Alma and Elisabet. The former is the nurse, played by Bibi Andersson, and the latter is her patient, the actress played by Liv Ullmann. In the prologue the juxtaposed faces are each fully lighted. Before they merge at the climax of the film, they are both systematically divided into black and white segments as if in a carnival mask that hides as much as it shows. Or, better yet, as if there were in each of the women an inner region that is not available to observation as the illuminated portion is. This effect recurs in *Cries and Whispers*, where the faces of Anna as well as the sisters she serves are presented in that

manner. In *Persona*, once the imagistic merging occurs, a whole face knits together two of the halves in each visage. But it cannot reveal the persona of a human being, particularly the complex personality of either Alma or Elisabet. Remaining separate in their personhood, they are inherently different—as Alma later insists—and the totality that now appears consists only of jumbled components.

What we see at that moment is an ugly, even monstrous, simulation of a face that distorts the handsome features that these women normally have as individuals. The composite is as repellent to us as an image of Mr. Hyde, in contrast to one of the upright and likable Dr. Jekyll. While drawing upon a parallel duality about good and evil, light and dark aspects of our nature, Bergman goes beyond the traditional motif that Robert Louis Stevenson successfully employed as well as his many followers in literature and in film, or even Renoir in *Le Testament du Dr. Cordelier*. In comparison with his predecessors, Bergman conveys the theme in a more resonant and imaginative oneness of facial features through which the camera fabricates a special effect that relies upon the unique chiaroscuro and arresting luminosity of the lighting.

The concept of merging is a fundamental component of Western philosophy. It originates with the

mythological fable that Aristophanes relates in Plato's *Symposium*. There it occurs as a creation myth, explaining how the human race came into existence after the gods divided the hermaphrodites into halves that henceforth seek to reunite themselves. It is also an erotic myth, since love is defined as the means by which the reunification is thought to originate. The persona that presumably results will be a superior entity, the ego and the alter ego turning into something more and better than either by itself. In the nineteenth-century ideology that saturated the culture Bergman inherited, the notion of Romantic love presupposed the absolute ideality of merging in attachments of sex, love, or marital union, and also in our species' relationship with the cosmos and its creator. That is what Bergman examines through his cinematic inspection of intimacy between his characters.

His investigation is prominent even in his early neorealist, and often grim, movies of the 1940s. They culminate in a 1949 work, *Three Strange Loves*, that reveals his command of the verisimilitude style of filmmaking as well as his modulated pessimism about interpersonal love. In the next few years films such as the masterful *Sawdust and Tinsel* (also known as *The Naked Night*) present similar views with greater inventiveness in the camerawork and much stronger intensity in the

dramatic action. But *Three Strange Loves* is especially interesting in relation to the concept of merging. Within its account of marital disharmony it touches upon the myth of Arethusa, the details of which both husband and wife seem to know. As reported by Ovid, Arethusa is a virginal nymph who tries to escape the sexual advances of the water god Alpheios. On her behalf Artemis, goddess of the moon and protector of women, changes her into an underground stream. But Alpheios does the same to his native river and follows her. As pursued and as pursuer, the two make an underwater trip together and finally resurface in Sicily. There the waters of the two forever intermingle in what is called The Fountain of Arethusa.

In *Three Strange Loves* the husband covets two silver coins minted by the ancient Greeks as reminders of what befell Arethusa. In his wife's dissatisfaction with him, she complains that he loves the coins more than he loves her. The myth these objects project keeps alive the ideal of marital merging that this couple cannot themselves attain or even approximate. After a nightmare in which the husband dreams of murdering the wife, this segment of the movie ends with both being reconciled to their need for each other despite the absence of any ideal or truly romantic love between them. In a subplot we have also observed another woman reject first the

proffered sexual intercourse thrust upon her by a psychiatrist and the lesbian affection suggested by a former friend.

These different types of attachment having been presented, the movie concludes with only a thin veneer of hopefulness for the future. Some critics have cited Bergman's admiration for a statement in Strindberg's plays to the effect that a bad marriage (or emotional affiliation of any sort) is not as bad as having none at all. This mode of reasoning characterizes much of what Bergman enunciates at the time, and specifically the ideas he develops in *Persona*.

The artfulness of that movie is typified by the fact that the central concept of merging is scarcely mentioned in it and certainly not elaborated by the narrator (Bergman himself), whose speaking voice we briefly hear. The work of inspection is almost entirely done by the camera, sometimes disjointedly but always in a manner that an audience can appreciate. Moreover, the camera has liberated itself from the necessities of linear progression that mimics the duration of real time. For example, when Alma has broken through Elisabet's shell and gotten her to utter a few words, we suddenly see the nurse enter a hospital room in which Elisabet is lying on the bed. Though all the recent action has occurred in the country cottage where Alma dresses

informally and sometimes in a bathing suit, she is now attired in the uniform of her profession. Elisabet has generally been shown sitting or walking or doing what people do on vacation in the country. But now she is stretched out inert and all but lifeless. Lifting her head and the top of her torso, Alma orders her to say two simple words—"No" and "Nothing." Once Elisabet complies, albeit faintly, Alma lets her lie back. The movie screen goes all white. Next we see a shot of Alma in the cottage.

From this we infer that what we have just watched was a dream or dreamlike reflection of Alma's about where they should be at this point—off the island and back in the hospital. She closes up the cottage, and Elisabet starts packing. By deviating from the realistic in that peremptory, and at first confusing, shift to the hospital room, the camera has not only moved the narrative forward as succinctly as possible but also transmitted the idea that Elisabet may still need institutional help although she is on the road back to normal behavior.

Earlier in the film the camera had performed similar feats of its magic. Soon after Alma has established her oneness with Elisabet, whatever it may mean, she meets Elisabet's husband on the island. He treats her as if she were Elisabet. Alma tries to convince him that she is not, but his gaze is blank, as if he might be blind, and

we don't know why he mistakes her for his wife. When the camera takes us back to the relationship between the two women, we realize that this has been a dream or thought experience that leads Alma to realize the absurd and perilous situation she has got herself into. The camera conveys all that by creating images of real possibilities without the pretense that ordinary reality itself is being presented either in itself or in some faithful representation of it.

Bergman makes his cinematic creativity overt and even startling in this way, but not as a Welles or Hitchcock might have done. In explaining the shrieking of the cockatoo in *Citizen Kane*, Welles said he wanted to wake up any members of the audience who might be succumbing to drowsiness that far into the movie. For Hitchcock, shock effects were designed to evoke strong feelings that pertained to suspenseful events in the plot. Bergman's cinematography in *Persona* is arresting, and possibly upsetting, however, because it is usually *a component of* the narrative rather than a mere vehicle to it. Without the use of symbols or hidden meanings, whether Freudian or Jungian or any other, his effort as filmmaker thereby focuses our imagination on some development in the plot that he has devised.

As a further illustration of this, consider the moment just before the end when Elisabet walks out of the cottage dressed in travel clothes and with a valise in hand.

She passes a primitive-looking statuette on a pedestal, and the camera zooms in on it for several seconds. The work of art consists of an upward-oriented human head, abstract and very dramatic, the interior hollow, the front somewhat fragmented, the mouth open as if in a declamation of pain or agony. The next shot shows Elisabet's face heavily made up for the role in *Electra* that she walked out of at the beginning. Showing the statue as it did and at that point, the camera prepared us for her return: it was saying that Elisabet has decided to live the life of a tragedian again.

We then see a large movie camera with a cameraman astride it. Since Elisabet had acted on the stage and not in the movies, we may take this as the filmmaker's assertion of his own aesthetic role. In any event, the effect is similar. Neither the statue nor the movie camera nor the actress's histrionic facial appearance has symbolic meaning. Instead they each function as active and transitional elements in the presentation of the story. They are not just intrusions of the filmmaker telling us that what we are watching is a make-believe of his invention, but rather a structural contrivance that deftly leads the audience further into the work itself.

In his voiceover commentary for the Criterion DVD version of *Persona*, Marc Gervais ascribes Bergman's techniques in this film to a "postmodernist" attempt to

"deconstruct" the pretensions of realistic narration. There may be some truth in this, but I think it must be seen in the context of Bergman's more extensive views about our reality as well as the nature of his art form. The fiction we have been following concludes with the chaotic display of tangled celluloid haphazardly traveling through its projection wheels, and this might be taken as an honest or apologetic reminder about the imperfections in all moviemaking. At the same time, however, shots of the young boy return at the end. He is the icon of a creative person who has taken us through our imaginative experience, equivalent to the magical Drei Knaben (three boys) who guide Tamino and Papageno in *The Magic Flute*. Like these fellow wonder-workers, he does not deconstruct anything. He has instead effected a means of seeing the world that purports to represent it truthfully. Though merging, in particular, is something we may long to have with some other man or woman, it has been shown to be an impossible goal in view of what it is to be a person. That is the principal thrust of Bergman's mythic work.

Nor is it fortuitous that he chooses for his protagonist a performing artist who appears on stage in masklike makeup that defines her theatrical persona. Even when Elisabet lies in bed in the hospital or the cottage, she wears the thick and artificial eyelashes appropriate

for a dramatic production. Her emotional problems stem from her inability to face the fact that she, like most other people, is always playing some role or other. She learns from her relationship with Alma that no communication, however well attuned and intimate, can alter that condition. The loneliness that results is ineradicable, and such that it prevents the achievement of any desired merging.

This outlook on the world is implied in the analysis of Elisabet's case that her psychiatrist delivers to her at the outset of her treatment. In a diagnosis that is humane and sympathetic as well as thoroughly truthful, the psychiatrist says to this patient:

Don't you think I understand? The hopeless dream of being. Not seeming but being. In every waking moment aware, alert. The tug of war—what you are with others and who you really are. A feeling of vertigo and a constant hunger to be finally exposed. To be seen through, cut down ... even obliterated. Every tone of voice a lie. Every gesture false. Every smile a grimace. Commit suicide? That's unthinkable. You don't do things like that. But you can refuse to move and be silent. Then, at least, you're not lying. You can shut yourself in, shut out the world. Then you don't have to play any roles, show any faces, make false gestures. You'd think so ... but reality is diabolical. Your hiding-place isn't water-tight. Life trickles in everywhere. You're forced to react. Nobody asks if it's real or not, if you're honest or a liar.

That's only important at the theater, perhaps not even there. Elisabet, I understand why you're silent, why you don't move. Your lifelessness has become a fantastic part. I understand and I admire you. I think you should play this part until it's done ... until it's no longer interesting. Then you can leave it, as you leave all your roles.

There is nothing that we learn in the course of the narrative to discredit that analysis. It is, in fact, an accurate answer to any questions we may raise about the pathological circumstances in which Elisabet exists throughout the film. Bergman tells the audience in advance all it needs to know in a way that is similar to Hitchcock's method of creating suspense by presenting all the evidence beforehand. Having heard the expert and convincing diagnosis, we are eager to find out whether Elisabet can actually play the part until it is finally done; and if so, how she will do it. But the kinship to Hitchcock's approach to a thriller, as opposed to a whodunit or a mystery story, ends at that point. The prior information is given by Hitchcock as a preliminary to a course of events, the gripping action that dominates the rest of the movie. The mature Bergman characteristically shows little interest in making movies of that sort. Having established the nature of a problematic situation, he wants to study its ramifications in his character's personality as well as in the humanity of

us all. This scarcely involves any manipulation of the audience's feelings, as in Hitchcock's technique. Instead, it stimulates our cognitive and affective probing into a reality we have in common with the fictional personage, and with each other.

At this point it is worth comparing the psychiatrist's speech at the beginning of *Persona* with the speech of the psychiatrist at the end of Hitchcock's *Psycho*. The latter is cumbersome and annoying, tedious in its content as well as in its length. After the measured, even fairly rapid, pace that Hitchcock has followed up to this terminus in the movie, we can only wonder why he slows things down so unnecessarily. Bergman's insertion of the doctor's remarks is inspired, fascinating in the perspective being offered and wholly suitable as a statement of the project in which the patient will be engaged as well as her nurse.

In other films, one of which I will turn to later in this chapter, Bergman portrays psychiatrists in various different ways. As for speechifying, he too errs occasionally. *Prison* concludes with tendentious comments by a film producer who definitively asserts that questions about man's search for God or any meaning in life are simply noncinematic, since there is nothing in the world that objectively corresponds to them. Apart from the relevant fact that Bergman himself reopens the issue

only a few years later, this unneeded declaration merely weighs down the film in which it occurs. Thereafter Bergman's works successfully exclude such heavy-handed statements about life.

As if it were a touchstone or synthesis of Bergman's aesthetic imagination as a whole, *Persona* introduces novel and frequent uses of his customary imagery of faces and hands. In addition to the progression from full-screen close-ups of the lovely faces of Andersson and Ullmann into the desecration of both by the fused composite, the faces in the prologue of stone statues and of the corpses that have been petrified by death also belong to the general conception. The same applies to the women's hands that touch each other's face, and sometimes their own—as when Alma repeatedly pushes her bangs off her forehead to see in the mirror whether she and Elisabet look alike. All these are visual stimuli that contribute to the corporeal rhythm of the imagery in this film. The open hand with a rivet piercing it, the fingers stretched out as if pleading for help, can be identified as Christ's on the cross, as many critics have, but in itself it too fills our mind with the autonomous idea of human suffering that preoccupies the entire movie.

The Christlike image occurs at the beginning and then again at the end, as a bracketing of the agony that

sensitive and aspiring people are forced to experience. In her desperation, Alma locks her hands together twice and pounds the table frantically. In a brief sequence that may only be imagined and not actual, Elisabet's hand crawls spiderlike up the arm of Alma before she bites into it and draws blood. What remains unresolved is the problem of getting in touch, being in touch, with another person, whose presence manifests itself in her face and through her face's accessibility to the tactile capacity of someone's hand. Bergman experimented with these realities in his early script for *Night Is My Future*, which deals with the plight of a blind man who uses his hands as an accomplished pianist would, but also in a constant attempt to reach out to the world he inhabits. In *The Touch*, Bergman returns to this basic notion when the erratic lover touches with his fingertips the face of the woman who doubts that he really loves her. The action is designed as a silent proof that he does. But neither of these productions has any of the daring and incandescence that makes the mythological philosophy of *Persona* so outstanding in the history of film.

Within the totality of Bergman's oeuvre, *Persona* illuminates the two prongs in his thinking about the possibility of interpersonal oneness by mingling the positive and negative strands I have mentioned. The final outcome of Elisabet's revulsion against the unreal-

ity of her previous life is neither idealist nor Romantic. Reality itself has not altered. Her principal mode of protest had been her self-imposed silence as an expression of her horror about the silence of the universe, and presumably of the God whom theologians had taken as the explanation of its existence. Her suddenly wanting to smile or laugh at the world that engulfs her can be interpreted as a realization of the absurdity of everything, both in herself and beyond, within the theater and outside. This is what she is now going back to. Like the priest in *Winter Light* she is condemned to survive as a participant in the meaningless silence that cannot be abolished.

At the same time, Elisabet's experience with Alma and in the hospital has been cathartic. Though her own silence is a performance in response to what each person undergoes in being human, she has managed to play through this fantastic part until it no longer interests her. She then leaves it, as the psychiatrist said she would, just as she leaves all her parts. Her career in the theater has given her the training that she can use for this eventuality. And though it has now occurred on a vastly larger stage, her interlude with Alma will have served as a rehearsal for the more finely attenuated simulacra that occur within the fictional settings of her professional endeavors.

Some twenty-five years after he made *Persona*, Berg-
man wrote that it "saved my life—that is no exaggera-
tion. If I had not found the strength to make that film,
I would probably have been all washed up.... Today I
feel that in *Persona*—and later in *Cries and Whispers*—
I had gone as far as I could go. And that in these two
instances ... I touched wordless secrets that only the
cinema can discover."[1] The coupling of *Persona* and
Cries and Whispers makes sense insofar as their film
technique is concerned. The cinematography and the
use of colors in the latter show an understanding of
the medium that often exceeds anything of this sort
in the former film. But the unremitting pessimism and
despair about human relations that pervade *Cries and
Whispers*, as in other Bergman movies of the period,
scarcely prepare us for the more optimistic works that
followed later on. In being an account of Elisabet's
renewed capacity for a productive life in the arts,
Persona leaves open such affirmative possibilities. It
thereby exceeds the affective parameters of *Cries and
Whispers*. While that work concludes with images of
happy days the sisters had together in former times,
Persona projects us into a future for Elisabet that may be
much better than her past.

Having already quoted from the meager but evident optimism that asserts itself in the last sequence of *Scenes from a Marriage*, I feel that I can turn directly to a film in Bergman's final work that is staunchly contrary, and indeed an extreme example of the opposite prong. *From the Life of the Marionettes*, made in 1982 and thus preceding *Fanny and Alexander* by only two years, is the most consummate and the most thorough exposition of Bergman's pessimistic vision. It is his only film in the German language and the only one enacted mainly by German actors. It is a powerful melodrama in a class with Hitchcock's *Psycho* or *Frenzy* and Welles's *Touch of Evil*. It goes beyond them, however, in being a fully realized deployment of Bergman's style and philosophic thought that he had honed for many years. Just as *Fanny and Alexander* is a pinnacle of his affirmative aspect, so too is *From the Life of the Marionettes* the completion of his negativistic fears about any human search for love and harmony, whether the object is oneself, one's sexual partners, one's society, or the cosmos at large.

An astounding achievement within Bergman's mythic and investigatory probing, *From the Life of the Marionettes* also includes a social and political setting suitable for the populist views that date back to his earliest movies. Their neorealism is wholly coherent

with the humanitarian and quasi-socialist perspective as adapted to narrative needs of the individual films. In *Summer with Monika* the dismal failure of the married couple is overtly linked to the social attitudes they have to confront from the very start of their relationship. In *Port of Call*, made five years earlier, we are left with the feeling that the young lovers might possibly buck the system and go on to a happy relationship despite its interference. Bergman tells us that he made *Port of Call* under the influence of Rossellini's neorealism, and like many of the Italian films of that era it depicts contemporary life as largely inimical to the personal values most people care about.

From the Life of the Marionettes is likewise an extension of Bergman's perception of political evil. That also appears in *Persona*, when Elisabet sees on television the footage of a Vietnamese man being shot in public and a monk setting himself on fire; in *Shame*, which graphically shows how warfare changes good-hearted people into murderous monsters; and in *The Serpent's Egg*, which demonstrates how the evil of Nazism arose out of the wretched conditions to which people had been subjected ten years before. In relation to those and similar films he made, Bergman remarked: "There exists an evil that cannot be explained—a virulent, terrifying evil—and humans are the only animals to possess it.

An evil that is irrational and not bound by law. Cosmic. Causeless."[2]

In *The Serpent's Egg*, though not in the other films I have cited, Bergman's social and political concern had a bad effect upon his study of the fictional characters he was simultaneously trying to present in conformance with his broader philosophical insights. In *From the Life of the Marionettes* this failing is rectified. It deals with the contemporary existence of upper-class Germans whose remarkable success in business turns them into what Bergman calls "emotional illiterates." In their pursuit of wealth and material well-being they have dehumanized themselves. Peter, the protagonist, murders and then sodomizes a prostitute as if in recognition of the evil that he too has caused as a prostitute of Big Industry.

The film begins by showing us Peter's crime in vivid color. The question Bergman seeks to answer is: how can it have happened? This approach runs parallel to the one that Hitchcock uses in *Frenzy*, an equally violent movie. Audience suspense having been established by his showing of the crime, Hitchcock then goes on to portray society's attempt to discover and apprehend the criminal. For Bergman that is a matter of secondary interest. Though he will finally replay in sensationalistic detail the murdering of the semi-nude prostitute, his

prime concern throughout is to analyze and explain Peter's character and motivation in killing this human being. No Hitchcock film comes even close to what Bergman achieves in that regard. In *Frenzy*, for example, our meager enlightenment about the psychopathic crime comes mainly from a police detective who is generally portrayed in a humorous relation to his ludicrous wife.

Nothing that lighthearted occurs in Bergman's movie. But as if to parody *Psycho*, which seems superficial by comparison, *From the Life of the Marionettes* ends with its own psychiatric diagnosis of the murder. Toward the beginning of Bergman's film, however, we have already encountered this psychiatrist when he betrays the confidence of Peter, his friend and patient, in an attempt to get Peter's wife Katarina to have sex with him. The sleaziness of the man makes us suspect everything he says, and in fact the lengthy statement he makes near the conclusion of the film is so trite a replica of textbook clichés that we distrust it completely. In writing later about this part of the movie, Bergman confesses that the psychiatrist's speech is really "a conscious hoax: a cynical codification of a bloody drama in slippery psychiatric terms."[3] In the film itself that effect seems obviously intentional and clearly conveyed. When I read Bergman's comment, I was fully prepared

for his closing remark: "Peter should have shot the doctor."[4]

When Peter kills the prostitute, without forethought and in a state of mindless perturbation, he does so after he has told his wife about a nightmare in which he murders Katarina herself. She is not overly alarmed about this, because she rightly perceives the real though fragile oneness that unites them. In spurning the psychiatrist's offer of sexual intimacy, she explains her refusal in terms of the bond that causes her to remain faithful to Peter. She says she loves her husband. In the long line of films that Bergman made, her monologue about what this means is the most comprehensive description of married love that he has ever given. Without being an affirmation of Romantic merging, it shows how far Bergman's realistic speculation about any such ideal had taken him. The following are the words Katarina utters and Peter hears while hiding in a corridor so that neither she nor the psychiatrist knows he is present:

Peter is a part of me. Can't you see. He goes with me wherever I go. He sits here. I've never felt that way with anyone. Maybe with kids it's different. Now we're each other's child. No, that's not true. Neither of us wants to mature. That's the reason we fight and torment each other and cry. Neither of

us wants to grow up. But we share one blood stream. Our nervous systems are connected. Understand? If Peter isn't well, neither am I. I want to run home and hold him and say: From now on I understand everything you say, think, and feel. I want to hold him tight until he notices me, because we don't see each other although we live so close and know everything about each other.

Katarina's statement can also be taken as a commentary on the marriage that Bergman depicted in *To Joy* as early as 1950. That film offers a portrait of a young couple whose intimacy includes conflict, anger, and duplicity but also an ultimate loving attunement in the happy family they eventually establish. When the wife is killed in an accident, the husband lives on in a manner that he would have been too weak and self-indulgent to attain at the beginning. He is a musician in a local orchestra, and he stoically performs his communion with that group in their rehearsal of the last movement of Beethoven's Ninth Symphony. The movie both starts and, after a long flashback, ends with it. The conductor, played by Victor Sjöström, tells his musicians and the chorus who sing the final paean based on Schiller's "Ode to Joy" that this music goes beyond all understanding of any happiness or suffering we might experience in actuality. We know he is thinking of the tragic death that has demolished the family. The couple's six-year-old son,

the only one who has escaped the accident, listens intently to the playing of Beethoven's rapturous attestation. He foreshadows the other boys in Bergman movies whose honest, probing, creative vitality gives hope that, even at its most painful, life and the search for love may retain a residual meaningfulness.

The psychiatrist says nothing throughout Katarina's long speech. Her account, and the conception of love she is formulating, would seem to make no sense to him. But in the semidarkness the face of Peter reveals how greatly her words penetrate his being. They are in fact fundamental to the cumulative analysis that Bergman presents in scenes before and after the horrible event that the film tries to explicate. In several episodes Peter discusses his condition in a way that avoids any slippery psychiatric talk while expressing the viewpoint that Bergman had been working at for decades in his films.

At one point Peter describes a dream he has had, and that we now see. In it he and Katarina are naked in bed. While she sleeps, his hand moves across her face and down to a nipple. In a letter to the psychiatrist that he never sends, Peter remarks: "Each finger had a little eye registering all the glittering surfaces and the gliding itself. It was fine. It could stay that way. I thought—or rather I didn't think at all—a colorful ribbon floated

out of my lips: If you are my death, welcome my death; if you are my life, welcome my life." After Katarina awakens in the dream, it turns violent but eventually becomes peaceful and benign. It ends with him curling up on her lap in the fetal position and resting contentedly in her arms.

In a later scene Peter threatens to kill himself by jumping off an outdoor balcony and has to be rescued by a colleague. Katarina has a hysterical fit in which she gives details about their abysmal sexuality. When she tries to apologize afterward, Peter coldly withdraws from her but characterizes his suicidal desire for annihilation as a longing to "blow himself up." "What remains?" Katerina asks. "Mincemeat, blood and nerves," he replies. She finds this unacceptable: "That's better?" In words that fill her with silent dismay, he answers: "At least closer to reality around me."

Earlier in the film we learned much of what that reality is. For both Peter and Katarina it pertains to their station as wealthy and upper-class professionals in the business world. We see glimpses of the traffic moving toward the industrial complex in which Peter is an important executive. In that capacity he dictates a long, repetitious, and all-but-incomprehensible memo to his lifeless secretary. It alone shows him in his role as a robot or marionette being manipulated by unknown

but mainly inhuman corporate powers in present-day society.

A brief glimpse into Katarina's work as a fashion designer leads to a conversation that she has with her associate Tim, who is ridden with self-hatred and a lingering feeling of humiliation in his life. He talks disparagingly about himself as a homosexual who is out of touch with his own personhood. He asks Katarina to take his hand and put it lightly on her face. She does that, and he says, "Feel my hand?" She nods yes. Yet when he then adds, "But feel it's me. This is me," she shakes her head in denial.

In the next scene we see Tim as he testifies to an inspector about the murder Peter has by then committed. He claims to have intuited that Peter was not only unhappy in his marriage but also latently homosexual. In his pervasively divided manner, however, he admits he can't be sure; he may have been mistaken. We are never given any reasons in the narrative to evaluate a judgment about this one way or the other. In his commentary on the plot, Bergman states, "When I watch the movie today, I feel that the character of Tim, a homosexual, is closest to the truth when he hints that Peter is bisexual. For Peter, the acknowledgment of his split sexuality would possibly have been liberating." Be that as it may, Bergman immediately goes on to say that

in the film he offers "a glimpse of this explanation in the final analysis made by the doctor."[5] But since that entire analysis is a hoax, we remain with little we can rely on in this connection.

Of greater significance, I believe, is the fact that when Peter describes his problems in conversation with Katarina he claims "there's no exit." In the actual murder scene, when he finds the doors are locked and he cannot leave the backstage quarters of the actress/prostitute, he repeats these words. We, like him, naturally think of Jean-Paul Sartre's play about people in hell. Being bisexual or latently homosexual is not itself a state of hell, but being an emotional illiterate, to repeat Bergman's phrase, and therefore alienated from one's own reality, certainly is hell on earth.

From the Life of the Marionettes is an outstanding film not only in itself but also as the continuation and ever more creative presentation of fundamental themes in Bergman's work as a whole. We observe Peter and Katarina in the context of the business world from which they come and which they discuss in *Scenes from a Marriage*, where they are minor characters who demonstrate the aggressiveness and proximity to violence that inheres in all human intimacy.

In *A Passion* we saw Max von Sydow wielding an ax and then bringing it down upon Liv Ullmann, but that

was only an assertion of his feelings by the camera. The image never materializes into a real event in the narrative. On the other hand, in an episode of *Scenes from a Marriage* after Johan and Marianne have had sexual intercourse prior to signing their divorce papers, they vacillate about taking the legal step but end up quarreling and finally striking each other in a bout of prolonged and hateful fisticuffs. After that, they both quickly sign the divorce papers. The occurrence puts them on a footing with the Peter-Katarina couple, who had seemed so inferior as married people in the first episode. All this is reinvented and resolved in the visualization and dissection that takes place in *From the Life of the Marionettes*. It explores the reaches of "senseless violence," as we call it, which are always lurking in *Scenes from a Marriage*.

In their appearance at the beginning of that film, Peter and Katarina are unattractive people and quite repellent in their somewhat inebriated bickering. In *From the Life of the Marionettes* they are more handsome and more recognizable as persons who have an authentically real though tortured life of their own. In the last episode, just before Peter goes beserk we see how greatly the pretty and compassionate prostitute enjoys the simple pleasures that everyone cherishes. Peter becomes enraged when she soothingly touches and

caresses his face with the fingers of her hand. We sympathize with the three of them, and their tragedy enables Bergman to provide a more exhaustive demonstration of the modern emptiness and despair that was present in *The Silence* but not fully examined there.

The contemporary world of massive economics contributes to that malaise by serving as an underlying cause of the unsavory lifestyle in *From the Life of the Marionettes*. Despite the seclusion of his elegant high-rise apartment, Peter cannot sleep well because at night he hears the traffic on the highway taking people to their employment. He longs for a purifying silence away from his meaningless involvement in this noise. But the industrialized city itself defeats any such escape.

After his terrible explosion, "the catastrophe" as it is named in the titles of the episodes, Peter does attain a kind of silence. It is, however, neither the silence of the grave, which he has envisaged in his suicidal moments, nor the silence in the soul that emanates from aesthetic experiences that can reconcile a person to the silence of God and our unresponsive universe. Instead, it is the silence of his catatonic state in the psychiatric cell he will have to inhabit for the rest of his life.

Here too the analogy to Hitchcock's *Psycho* may disclose something worth noting. In the final shots of Norman Bates we see him in his mother's shawl,

speechless and cut off from communication with other people. But he is not entirely silent. In a voiceover we hear him talking to himself with an unreal voice that mimics the sounds that would have issued from the mother with whom he now identifies totally. Bergman's finale is more telling though not as blatantly melodramatic. After all of Peter's verbalized effusions about his feelings, his marriage, and the reality in which he thinks he is immersed, he has nothing more to say in the terminal episode. Within his living death he briefly plays chess each morning with a computer, largely ignores his keepers, and seeks creature comfort only by touching a ragged teddy bear he had in childhood. He is left with the silence of this personal Rosebud as the relic of a goodness in life that he can no longer have.

Though played by different actors who speak German rather than Swedish, the Peter and Katarina of *From the Life of the Marionettes* are, as I said, the same as the Peter and Katarina of *Scenes from a Marriage*. They are also latter-day versions of Mr. and Mrs. Alman, the unhappy married couple in *Wild Strawberries* who are asked to leave Borg's car and who later take their revenge in the nightmare sequence during which he is found incompetent. In films like *Three Strange Loves* their kind of

symbiotic misery also had no exit, although the suffer-
ing couple in that story manages at the end to soldier
on in a hapless quest for Arethusa's fountain.

Various commentators, including Peter Cowie and
Robin Wood, assert that Bergman's films are all voy-
ages of some sort.[6] That is true about a few of them,
most notably *The Seventh Seal* and *Wild Strawberries*, but
somewhat inaccurate about many others. More helpful,
I think, is Hitchcock's suggestion that most good films
inherently embody one or another type of search. In
Bergman's case the greatest search is his own as he
turns from one film to the next in a long succession of
works that vary, modify, extend, and augment motifs
that are pertinent to what has meant the most to him in
the real world. Thus the horrid psychiatrist in *From the
Life of the Marionettes* is a revisiting of the similar charac-
ter in *Three Strange Loves*, but much more deeply
conceived and artfully fleshed out as a result of the
intervening years of Bergman's maturation. In that
sense all his productions may well be considered parts
of a cinematic voyage of search and research arising
from his own experience both in filmmaking and in
living as a human being.

With that before us, we can see the links between
the two Peters and Katarinas. In *Scenes from a Marriage*
their virulent behavior occurs at the beginning as an

embarrassing but evident contrast between their marriage, teetering on the edge of divorce, and the stable, apparently successful one that Johan and Marianne enjoy. What we don't know until later is that the difference between the two couples is less extreme than it first seemed. It is as if the poison in the one has migrated into the other. In the final scene from which I have quoted we see how Johan and Marianne reattain, or possibly exceed, some of the authentic value they once shared in their marriage. It has been impaired by their divorce, but obviously Bergman does not consider that to have principal import. Years after the television series *Scenes from a Marriage* became a sensational worldwide hit, Bergman mentions in an interview that the divorce rate in various countries soared phenomenally as a result. He says this with delight and an air of achievement on his part, adding that many people who should have gotten a divorce might not have done so otherwise. The arrangement that Johan and Marianne finally effect must therefore be seen as a felicitous though imperfect solution to the interpersonal problems that belonged to their relationship, just as they do, in part, to everyone's.

In *From the Life of the Marionettes* we perceive the fruit of Bergman's ongoing deliberations about the possible outcome of a marriage such as the one that Peter

and Katarina have. In *Scenes from a Marriage* they get a divorce early in the story. But what would their union have been like, Bergman seems to say, if they did not? Their strong attraction to each other can be considered a kind of love, but since it exists in an attachment shot through with mutual and self-oriented hatred that constantly soils their devotion to each other, what is the justification for that love? In the later movie Bergman deploys the vast array of technical inventiveness that he had by then amassed in a consecutive attempt to answer such questions as he never could before.

In three of the films that followed *From the Life of the Marionettes*—*Fanny and Alexander*, *In the Presence of a Clown*, and *Saraband*—Bergman continues his investigation. A 2003 sequel to *Scenes from a Marriage* (1973), *Saraband* takes us to the current state of affairs between Johan and Marianne after thirty years. Though they have not even seen each other for a long time, they become involved as grandparents do with the life of the daughter of Johan's son by a former marriage. In the final scene the two elderly people are naked and in bed together as they used to be. The drama of Johan's granddaughter has reestablished the intimacy they once experienced. It is different now, but there still exists a

substantial bond that makes us feel that their relation has weathered the stormy interval, for better or for worse. As they press against each other in the narrow bed, their passage through life seems to have been rewarding though not ideal.

Bergman leaves us with this version of his permanent ambiguity, but his supreme articulation of it here is a triumph of the human spirit. He never doubts for a second that aesthetic achievements may lead us to such heights. The art of Bach, in particular, dominates the thematic texture of *Saraband*. So pervasive is the grandeur of this music throughout the film that it even intimates a final harmonization with the religious views that Bergman had struggled against in his earlier life. In one scene Marianne visits a small church in which the granddaughter's father happens to be rehearsing a Bach sonata on the organ. Afterward they talk and Marianne detects a strand of mental and emotional instability in this man that will affect much of the following narrative. When they part, she feels appropriate worry and agitation about him in his effect upon his talented daughter.

As Marianne begins to leave the church, a burst of sunlight streams in through the upper windows. She pauses and turns toward the altar, behind which there is a garish porcelain tableau of the Last Supper, with

John lying like a dependent child across the lap of Jesus. Their posture is reminiscent of, but revises, the one in Michelangelo's *Pietà*, which Bergman copied in *Cries and Whispers*. Instead of Anna holding dying Agnes in that film as the Virgin Mary does with the dead Christ, the living Jesus in the chapel looks boldly at us as he sustains his beloved friend. Marianne stares at the tableau with a look that is wholly ambiguous. She closes her eyes and clasps her hands in meditation. She seems to be trying to equilibrate between two alternate responses: one that takes the sudden sunlight as a life enhancement comparable to the beauty that she has just heard in the Bach composition, performed within a church setting for which it was written, and another that confronts the meaning and the possible spirituality of whatever theistic doctrines inspired Bach's music as well as the crude altarpiece and its primitive representation of human love.

In Bergman's comments to the actors prior to the filming of this sequence, as recorded in the documentary on the *Saraband* DVD, he tells them about the intense fear of death that he felt when he made *The Seventh Seal* and that he overcame in the making of that film and its sequels. He asserts that for many years he remained comfortable in the relief that eventuated, but then it was shattered by the death of his wife Ingrid.

She had been his fifth wife, with whom—as he states elsewhere—he had been blessed in having almost twenty-five years of marital happiness. Her death challenged his composure in ways he does not fully delineate to the actors but that are relevant to what occurs in the exchange between the father and Marianne. Bergman says he had difficulty adjusting his belief that there is nothing after death to his painful need and infinite desire to see Ingrid. When he told Erland Josephson (Johan in *Saraband*) about his inability to go on living without the hope of ever seeing her again, the following exchange resulted: "Erland said: 'What do you really want?' and I said, 'I want to see Ingrid.' And then he said, very wisely, 'Then hold on to that.' That's one of the most valuable pieces of advice I've ever had. Imagine, we've—all of humanity—has thought endlessly about death. Since the beginning of time, not knowing. Can you imagine that it's so incredibly simple?"[7]

While Bergman reports his present ideas about death, the camera lights upon Ullmann's face as she listens with furrowed brow and concentrated expression to the words of the man she lived with for several years, the father of her child, the director of many great performances she gave under his tutelage, and the screenwriter of two movies that she had directed herself. Bergman tells the actors that what he is saying

is "the key ... the core of this text." And indeed it all enters into the father's suicidal confession to Marianne in the church.

In that scene Ullmann's Marianne listens attentively as the father portrays the anguish that has engulfed him since his wife Anna died two years earlier. Her benign photo image flashes upon the screen to emphasize what he is saying. Several reviewers have asserted that in reality it is a photo of Ingrid, to whom Bergman dedicated this film. In a recent conversation, however, Ullmann informed me that the photo is of someone else. The father tells Marianne that only his daughter Karin has any meaning to him now. He imagines a day when he will be walking alone in absolute silence through the woods, and suddenly he will see Anna moving toward him. "And then I realize that I'm dead. Then the strangest thing happens. I think, is it this easy? We spend our whole lives wondering about death ... and what comes after. And then it's this easy. In music, I can get a glimmering. Just a glimmering. Like in Bach." Marianne nods and responds: "I think I understand."

As in Bergman's suggestion about the key or core of the text, the details of this understanding are not readily evident and are possibly beyond the scope of total clarity. A solution to the problem of death has not been stated. Nor should one expect it to be in a work of

art that remains true to the uncertainties of human experience.

In *Saraband*, as in the previous films of Bergman that examine interpersonal love, with a few exceptions, no one says to another person "I love you." Those words appear in *The Touch*, uttered in the beginning by the American stranger and then at the end, when the woman tells her lover that he is too unstable for her to live with him any longer. They also occur in the movie Bergman made six years before *Saraband*. *In the Presence of a Clown* deals with Granduncle Carl who appears in *Fanny and Alexander* as well as in other semibiographical films about Bergman's immediate ancestry, such as *The Best Intentions*. Carl is now an inmate of a mental asylum. Though he occasionally becomes confused, his active mind tries to imagine and create the first talking picture. The young woman in his life at the time stands by him through the fiasco that ensues, playing the piano as well as performing in his wildly fictional screenplay about Franz Schubert. After it has all come to nought, she attempts to keep him from committing suicide by telling him that she loves him. At the end Carl is still beset by the demons that regularly torment Bergman's characters, but the woman's love remains as a positive resource that keeps him alive.

The clown in the title of that film is a white-faced apparition, like Death in *The Seventh Seal*, who

frequently appears to remind Carl of his coming demise. This particular figment is a vulgar female, dressed in a festive blue outfit and amenable to a coital phantasy in which Carl indulges his libidinal appetites. Poignant yet menacing chords from Schubert's *Die Winterreise* recur to underscore the imminence of the cold annihilation toward which Carl is voyaging. The young woman who loves him cannot obliterate either his mortality or his mortal inclinations, but she respects his personhood in a society that hardly comprehends the nature of his madness.

Saraband ends with a comparable uplift, not only when Johan and Marianne snuggle in the narrow bed but also when Marianne visits her silent and demented, or radically disturbed, daughter in the asylum where she now permanently resides. The situation is parallel to the one that Ingrid Bergman's character could not handle in *August Sonata*. But with her more obvious loving-kindness, Marianne is able to. Looking earnestly at the young woman as she sits on the edge of her bed, Marianne puts out a hand and with its fingertips gently strokes her daughter's inexpressive face. This is the gesture of the prostitute that led to Peter's murderous insanity in *From the Life of the Marionettes*. He was emotionally blind to its humane overtones. When Marianne proceeds to take off the daughter's glasses, a smile of receptivity traverses the features of the poor creature.

At some level of her being, she seems to understand and welcome the love her mother is extending through that unexpected communication.

This culmination is a terminus not only in *Saraband* but also in a major part of Bergman's searching. In *Cries and Whispers* he had studied death to some extent as a mythic principle (as in *The Seventh Seal* and *The Silence*) while simultaneously treating it as a natural process to which people are all subjected after having been alive. In his notebooks he calls *Cries and Whispers* a "poem: a human being dies, but as in a nightmare, gets stuck half way through and pleads for tenderness, mercy, deliverance, something. Two other human beings are there, and their actions, their thoughts are in relation to the dead, not-dead, dead. The third person saves her by gently rocking, so she can find peace, by going with her part of the way."[8]

In *Cries and Whispers* the third person is Anna, who is a loving and devoted person but only a servant. In *Saraband* her equivalent is Marianne, the mother of a neglected child who lives in the misery of dead but not-dead that constitutes the psychotic state she—like the protagonist in *Through a Glass Darkly*—is forced to experience. Planning what he would do in *Cries and Whispers*, Bergman wrote: "One scene I envision is when the sisters, in a state of despair, touch each other's faces

and hands, unable to speak."[9] In the film itself Maria initiates at first a rudimentary effort of that sort with Karin but it is not reciprocated and ends disastrously, causing revulsion and emotional distress in Karin. When they later make up and exchange the gestures of facial touching, we know that the event is ephemeral. Being part of a tragic inversion of the Cinderella story, the two sisters fail completely in their awkward attempts to make contact with one another. Marianne succeeds in this regard.

Many of these effects that we have been discussing were introduced by Bergman as early as *Dreams*, a film he made in 1955, the same year as *Smiles of a Summer Night*. Attention to hands, the touching of faces as an expression of love, the sheer difficulty of allowing or attaining romantic oneness—all this appears in *Dreams* as elements of its story about two women. One of them, a young model, is showered with expensive clothes and jewels by an elderly and presumably very kindly man, but her illusionary dream about him is shattered when his daughter reveals that he is as hard-hearted as Borg is said to be at the beginning of *Wild Strawberries*. The second woman is mature and success-ful in her profession. Her passionate but unavailing love for a married man disintegrates after his wife punctures her dream by convincing her that he is too

weak to abandon their children, as well as her consider-
able wealth. As Bergman developed in the course of his
filmmaking, he drew upon these and related motifs.
The pottery he molded took varied shapes, but the clay
he used throughout was fairly uniform.

Some people find Bergman's films depressing or hard
to like, and it is true that he offers no pat or easily di-
gestible solutions to the problems posed by humanity
as he knows it. Some of his earliest films, written to
make money, as he admits, do finish with these slight
conciliatory endings designed to calm our fears as we
leave the theater. For the most part, however, he
remains faithful to his mission as a thinker who has
learned how to study areas of life that no scientist and
few other artists can explicate as well as a talented film-
maker like himself.

At the same time, his view of our situation on the
dirty earth and under an empty sky is not gloomy or
resentful. Unlike Strindberg, whose writing meant so
much to Bergman, his last films often bristle with good
humor and undisguised delight in the foibles of our
fellow men and women. *Sunday's Children*, which Berg-
man wrote and his son Daniel directed, is a fascinating
and heartwarming account of Bergman's life with his

father, mainly when he was eight years old. Except for the fact that it is more thought-provoking, it belongs in the same category as the American film *The Human Comedy* almost fifty years before and based on William Saroyan's novel of the same name. In *Sunday's Children* the child Ingmar is presented as another instantiation of the precocious young boys whose wholesome curiosity sustains their imaginative inquiries throughout the films in which they appear.

Among the works of Bergman's late maturity, *Fanny and Alexander* best unites the two prongs of the ambiguity I have been discussing. In one of his notebooks prior to its production, Bergman mentions that his movie will include "an uncle who is a little crazy but is harmless and who takes certain liberties."[10] This is the same Granduncle Carl who eventually dominates every scene of *In the Presence of a Clown*. While that film remains highly modulated throughout, *Fanny and Alexander*, in which Carl's role is minor, is oriented toward an image and ideal of happy family life that Bergman nostalgically remembers as similar to what he himself may have experienced as an eleven- or twelve-year-old.

That is the age of the alert and perceptive Alexander, who represents him in the fictional narrative. From the start Bergman intended this film "to move in complete freedom between magic and oatmeal porridge, between

boundless terror and a joy that threatens to burst within you."[11] In his preparatory notes he reports that he wants "to depict, finally, the joy that I carry within me in spite of everything, and which I so seldom and so feebly have given attention to in my work. To be able to express the power of action, decisiveness, the vitality, and the kindness. Yes, for once, that would not be a bad idea."[12]

In comedies that date back to Bergman's beginnings, there were always intimations of this intention; and in *Smiles of a Summer Night* the joyfulness of erotic and romantic abandon plays a major part in the final outcome. Nevertheless, *Fanny and Alexander* uniquely enlarges the scope of that to include a very large family and the domestic ease of upper-middle-class affluence that some people had in pre–World War I society, as well as their divergent ideas about sexual morality. Moreover, this Dickensian panorama occurs in conjunction with the life of the theater—as it does in Dickens and also Goethe—its sadness and its mirth, which in Bergman's own reality becomes the bloodstream of his existence and of everything he creates.

The entire plot of *Fanny and Alexander* is enclosed within the two ebullient occasions at the outset and the end: one being the Christmas party with its long conga dance of life in which everyone participates, holding on

to whoever happens to be in front; the other being the celebration of the birth of two children that includes a dinner served at a huge circular table that looks from above like an enormous halo or festive wreath. In his closing speech Uncle Gustav Adolf, whose wife has tolerated his love for a young nanny in the house and who has fathered the nanny's baby, delivers a long paean in honor of the goodness of natural pleasures and the happiness of the family oneness they are all enjoying at that moment. This is obviously what Bergman wishes to communicate as the meaning in life.

Who can ask for anything more? During the twenty years that separate *Fanny and Alexander* from his last masterpiece, *Saraband*, Bergman in no way contravenes the positive impact of the former film. Existing as it does within the setting of the twenty-first century, *Saraband* portrays our emotional and spiritual problems differently, but with a freshness of cinematic inspiration that shows how continuously Bergman's creative powers developed throughout the sixty years of his career and into the present. Though it is less assertive about the solutions that may yet be available in the modern world, *Saraband* leaves us with some, at least, of the hopefulness that *Fanny and Alexander* formulates as a baseline in the past.

Epilogue

In an interview Ingmar Bergman gave when he was in his eightieth year, he states that he is "not a religious man."[1] He nevertheless repeats his earlier assertions about the holiness in every person. One might conclude that his attitude toward the orthodox faith in which he was born had not altered greatly in the years since he made *The Seventh Seal* and the movies that followed it. In those remarks to the actors about the scene in *Saraband*, he did not revise his disbelief about life after death: he merely expressed his painful realization that he would never again see his wife Ingrid. That feeling was a complication, what he calls a "problem" with which he was trying to cope. His stance with respect to other religious questions would seem to have remained unchanged.

Commentators who think that Bergman had all along espoused an immanentistic view do not take his

statements about being an atheist at their face value. In a previous chapter I discussed Jesse Kalin's suggestions of that sort. In a 1999 book, Marc Gervais claims to have detected a significant modification in Bergman's reaction against the Lutheranism of his father. The principal source cited by Gervais is the film *Private Confessions* that Bergman wrote and Liv Ullmann directed in collaboration with him.[2] It was a television production based on Bergman's novelette of the same title. It eventually become a somewhat shortened movie that appeared a few years earlier than *Saraband*. I see it as an amplification of Bergman's thought and creativity throughout his career, and therefore a fitting continuation of the moral and religious ideas he had previously offered, rather than a deviation from them.

Private Confessions is the third film that Bergman wrote in the 1990s based on the family of his mother and father. In *The Best Intentions* we follow the couple's turbulent courtship and difficult early marriage, his father being a severely dedicated preacher and his mother a loving but headstrong woman whose spoiled and favored upbringing encouraged her to go beyond the conventional limitations of the time. In *Private Confessions* Anna (the name Bergman affixes instead of Karin, his mother's name) finds that the love that she felt at first for her husband Henrik has dissolved under

the burdens of motherhood and the duties incumbent upon a parson's wife. Above all, she has had to put up with his pathological moodiness and unstable conduct. In his weakness, she claims, he has forced her into the position of treating him as if he were her constantly dependent child, what she scornfully calls an "adult child."

Though she has been a tireless consort for him, in her thirties Anna takes a younger man, Tomas, as her lover. He too is on his way to becoming a priest, and in fact he is a much gentler and more simpleminded adult child than Henrik. He initiates their escapade by using the magic words "I love you," but Anna immediately seizes upon the opportunity to have a true romance at least once in her life. She takes charge of their relationship and leads Tomas through their furtive and guilt-ridden search for sexual pleasure.

The narrative begins when Anna happens to encounter in the street her uncle Jacob, the priest of her parents' family. She has not seen him for some time, but he loomed large in her life many years before, when she was preparing for her confirmation. She now turns to him for help in the turmoil that her secret and very uneven love affair has brought upon her. In the course of the story we see both Henrik and Tomas as they relate to Anna, though never together at one time.

But the main male figure in this work is Uncle Jacob. He is played by Max von Sydow, who also enacted Anna's father in *The Best Intentions*.

In this conversation, Uncle Jacob strongly advises the distraught Anna to stop lying about her life, to tell Henrik the truth, and to separate herself completely from Tomas if only because their liaison could be ruinous to his career in the church. Though Anna claims that Henrik would crumble under this disclosure, Jacob argues that he might rise to the occasion and find a means of bestowing love upon her that would dissolve her feelings of guilt as well as his jealousy. When Anna continues to insist that Henrik is incapable of handling the situation in that manner, Jacob maintains that there is no alternative, since committing violence to what he calls "the Truth" inevitably leads to going wrong and doing harm. In this context, an exchange occurs between Anna and Jacob that Gervais considers crucial to his idea that Bergman's religious views may now have altered:

"Do you believe in God, Uncle Jacob? A Father in Heaven? A God of Love? A God with hands and heart and watchful eyes?"

"All that's unimportant to me."

"Unimportant? How can the form of God be unimportant?"

"Don't say that word 'God.' Say The Holy One. The Sanctity of Man. Everything else is attribute, disguise, manifestations, tricks, desperation, ritual, cries of despair in the darkness and the silence. You can never calculate or capture the Sanctity of Man. At the same time, it's something to hold on to, something quite concrete. Unto Death. What happens thereafter is hidden. But one thing is sure: we are surrounded by events we do not grasp with our senses but that constantly influence us. Only the poets, musicians, and saints have given us mirrors of the Unfathomable. They have seen, known, understood. Not wholly, but in fragments. It is consoling to me to think about the Sanctity of Man and the mysterious Immensities surrounding us. What I am saying to you now is not a metaphor, for it is reality. Inscribed in the Sanctity of Man is the Truth."[3]

Though Uncle Jacob is only one among other characters, what he says here is worthy of special attention because he remains throughout a sterling, wise, and compassionate man. Bergman could very possibly have given him a speech that, in part at least, expresses the author's own opinions. I think they do represent some of the views that Bergman held himself, and stated on various occasions, during the past forty years. In the 1970 interview, in which he says that his atheism gives him peace of mind because it frees him of any sense of worthlessness compared to icons like God or Christ, he affirms his belief in the "holiness" of all human beings

and his desire to do good works in conformity with that belief. He ends with words of advice for "the church," presumably the Swedish branch of orthodox Christianity. "What the church of today has to do," he states, "is to tell people about this holiness [in everyone], to educate them to listen to that holiness, to come into intuitive contact with this part of the soul."[4]

This message, which Bergman is unlikely to have found in his mother's diaries, he puts into the mouth of Uncle Jacob as basic to the dramatic structure of *Private Confessions*. The film is a story about a remarkable woman who falls in love with the wrong man, Henrik (Erik, Bergman's father), who pays a large emotional price in remaining his wife as best she can, and whose attempt to ameliorate her condition through love for another man compounds her disaster. In the last sequence, which is a flashback to the day before Anna, at the age of eighteen, is due to take her confirmation, she confesses to Jacob that she fears it would be a lie since she has no religious faith. She tells him that she wants to be of use to the world by becoming a nurse. She affirms, "When I decide something, then it becomes what I want. What are you thinking, Uncle Jacob?" He replies: "What am I thinking? Well, you never have to say 'I love you.' But you can carry out deeds of love."[5]

In *Saraband* this idea recurs when the dead but beatific mother of the young cellist is described as someone who does not say "I love you" but "continuously performs acts of love." Eventually the Anna in *Private Confessions* does become a nurse, like Bergman's mother, and carries out the deeds of love to which Jacob refers, though imperfectly in her marriage. When she says "I love you," first to Henrik/Erik and then to Tomas, she suffers for it—as the protagonist does in *The Touch* when the suicidal man utters those words to her. Uncle Jacob remains throughout as an examplar of how a good and wholesome person can fulfill his mission in life by doing good deeds coherent with the inherent sanctity of other people.

Henrik collapses and cannot equal him. Anna likewise fails in comparison to her friend Märta, who is a counterpart to Jacob in the narrative. She is a missionary nurse who listens sympathetically to Anna's troubles, and whose entire being is given to the service of others in practical and meaningful ways. At one point we learn that she is reading Kierkegaard's book *Works of Love*, which disdains Romantic ideals of love and holds aloft the love of God as the only source of any genuine love of humanity. Characters like Jacob and Märta do not appear in other Bergman movies. Another

book by Kierkegaard enters into *Saraband*. It is *Either/Or*, his first and most tentative production, designed to portray a soul that struggles with widely alternate approaches to religious questions rather than one that finds peace in a definitive solution to them. Johan, who hates himself and is vicious toward his son, reads the book in the library of his house which looks self-enclosed like a place of imprisonment.

The films before and after *Private Confessions* do not include married couples who have lived together in true happiness for anything like fifty years. The novelette intimates that Jacob and his wife Maria have done so, and in both the film and television versions that achievement takes center stage. To this extent *Private Confessions* is a reaffirmation of the positive elements in *Fanny and Alexander*, and possibly a reflection of Bergman's marriage to Ingrid. This development in his creativity need not be interpreted, however, as a latter-day move toward orthodox religiosity on his part.

During an interview he gave in 1958, Bergman characterizes his ideas about religion as follows: "I believe in God but not in the Church, Protestant or any other. I believe in a superior idea that we call God. I want to and have to. I believe it is absolutely necessary. Integral materialism could only lead humanity to an impasse without warmth."[6] It was afterward that he repeatedly

called himself an atheist and insisted that "what might exist beyond this world, does not exist. Everything is of this world. Everything exists and happens inside us, and we flow into and out of one another. It's perfectly fine like that."[7]

Furthermore, the underlying spirit in Jacob's conception of religious faith was already articulated by the bishop who officiates after the presumed death of Agnes in *Cries and Whispers*, made in the early 1970s. She too was his confirmation child, but he claims that her faith was stronger than his own. After the routine words he recites as a priest who does use the term "God," he says to the corpse: "Pray for us who have been left in darkness, left behind on this miserable Earth with the sky above us, grim and empty. Lay your burden at God's feet, the whole of all your suffering, and plead with Him to pardon us.... Plead with Him that He may make sense and meaning of our lives."

Cries and Whispers differs from *Private Confessions* in being an interrelated examination of both the agony in the actual dying of a woman and the death-in-life that her two unloving sisters must endure even in their attempts to touch each other. Only the devoted servant, who at different times strokes each sister on the face, escapes their torment. In *Private Confessions* Uncle Jacob and his wife have indeed made sense of their marriage,

as the bestowal of meaning that the bishop was plead-
ing for and that Jacob views as the fruit of one's belief
in the "Sanctity of Man." Like the sisters in *Cries and
Whispers*, Henrik and Anna cannot attain any such
fulfillment. Their mutual punishment, as Alman in
Wild Strawberries says about Borg's adulterous wife, is
loneliness.

Trying to explain her life to compassionate Märta,
Anna asserts that her love affair is itself a reaction to
the loneliness she has experienced in her marriage with
Henrik. She then adds: "I mean *utter loneliness*, the lone-
liness at the moment of death, the loneliness of the child.
I know, Märta! You're never alone. You live in the hand
of God. No, *alone* . . . that's actually clear. And then
Tomas came into my loneliness. And now both he and I
can say: We are not alone."[8]

Anna will thereafter learn how greatly deluded she
is in this opinion. The depiction of her permanent suf-
fering and sad resignation to it puts her in the class of
any number of characters in Bergman's earlier films.
They all represent what Jacob calls, in the passage from
which I quoted, the sorrows in a life of "attribute, dis-
guise, manifestations, tricks, desperation, ritual, cries of
despair in the darkness and the silence." In *Faithless*, the
later Bergman/Ullmann film, the same is also true.

This unity within Bergman's movies is accentuated by the recurrence in *Private Confessions* of his prior fascination with hands and faces, though there are fewer close-ups and more middle shots than in most of the movies he directed himself. After Jacob's discussion with the eighteen-year-old Anna in the final flashback, he briefly touches her face with his hands as a sign of loving-kindness, just as Anna had done when, in the previous episode, she visited him, her old friend who was now dying. In the first of their meetings she remarks: "I was looking at your big hand, Uncle Jacob. And I thought if God has a hand, which I don't believe, but if God has a hand, then it looks like yours. Then I thought about the hymn: 'Last, My Lord, I thee pray, take my hand in thine.'"[9] Alone with her timorous lover Tomas, she tells him that he has a good hand, and that when she first noticed it she thought: "That hand [followed by dots to accentuate her meaning]."[10]

In his jocular manner, Jacob says at one point how glad he is to see Anna face-to-face. He is not playing with Saint Paul's assertion of what a believer can expect to find by looking directly at God and seeing the ultimate truth. He is referring to the absolute communication that the two of them can count on in the purity of love they have for each other. The irony that pervades

their conversation just before his death issues from the fact that Anna lies to him about her existence as it has been during the ten years since she originally told him of her adultery.

Though she is miserable in the marital state she still endures with Henrik, Anna bravely invents an account that will allow Jacob to die contentedly and with no regrets about her condition. She pretends that she took his advice to break off immediately her relationship with Tomas, and to tell Henrik the truth about the affair that she had been hiding from him. We have seen her confide in her husband, but the results were disastrous; and we know that Tomas left her when their love affair petered out after a few years. In a segment that occurs in the novelette and the television production though not in the shortened film version, Anna reveals to her mother the ghastly details of Henrik's physical and mental breakdown in response to what he has learned, and how it has accelerated the deterioration of their marriage. To Jacob on the point of death, Anna concocts a fictitious picture of matrimonial friendship and pastoral work together, which reassures him completely.

The ending of the novelette differs from the one that Ullmann attached to both the television and theater movies. After Jacob has had a fit of vomiting, Anna wanders into a room where she finds a photograph of

herself and others in the confirmation group that Jacob had counseled. In the terminal flashback, after she tells him that she has doubts about participating in the communion for which he has been preparing her, he tries to help her make her decision. But when they part, she is still wavering. The novelette leaves the matter unsettled, and with a slight mention of their going back home in different directions.

In Ullmann's variation, which is said to have made Bergman "furious" but to which he finally acquiesced, we see Anna's saddened, weary face as she remembers that momentous day. We see next an image of the young girl she was then, who now turns around and smiles pleasantly in the direction of the camera. Her older self thoughtfully digests this show of confidence and goodwill. As the screen goes black for the last time, a thin and somewhat uncertain smile briefly softens her facial expression.

Relating Ullmann's firsthand description to him, Gervais quotes her as having said: "I had to tell him that the film could not *end* as it did in the script, with nothing resolved, heading nowhere. There had to be a point to it all."[11] I think Ullmann may have been right, and that her alteration was an improvement. But still the meaning of the girl's looking back—the "point to it all"—is not entirely evident. I myself think that

Bergman wanted to have nothing resolved, as a means of indicating that a reflective and conscientious person like his mother, even as a girl, was right to have questioned the dogmas to which she would be committing herself in taking communion as desired by her parents and her beloved mentor. At the same time, we know that Anna must have done so many times in her life with Henrik. And we have just seen her go through the ceremony out of respect for Jacob and Maria, reticent and reluctant as she seemed to be.

In the slight uplift of the girl's cheerful contact with her older self, and in Anna's minimal smile, we are given reason to think that her existence thus far has not been totally wasted. She did become a nurse, she did raise the three children including Ingmar, and despite the tribulations of her marriage she did live up to Jacob's conviction that doing good works for the sake of others is superior to the selfish goodness of romantic love. As Bergman said about the ending of *Winter Light*, in which the priest who has lost his faith and most of his will to live forces himself to go through the unifying rite of communion with his parishioners: "*irrespective of everything, you will hold your communion.*"[12] One might say that the bit of rejuvenating "light" that faintly shimmers through the spiritual winter in that movie issues from the persuasiveness of this concluding in-

junction. The same happens in the finale of the television and film versions of *Private Confessions*, though less obviously in Bergman's novelette.

What seems to me more problematic in this region of his thought, both early and late, is not the ambiguity of his affirmations but their vagueness. Calling oneself an atheist or substituting "The Holy One" for "God," as Uncle Jacob does, is a verbal issue about which we need not quibble. But throughout their statements of faith in the holiness of each person, of humanity in general and as a conglomeration of sanctified individuals, Bergman and Uncle Jacob alike seem to waver if only in retaining the more substantial religious language that insistently resonates within the established credo that they repudiate. Similarly, in referring to the mysterious immensities that surround us, and then saying that he finds the thought of them consoling, how can either Bergman or Uncle Jacob be led to any enunciation of some definite and particular Truth—capitalized in the manner of orthodox belief?

In an interview with Ullmann in 2001, she says of Bergman: "Although he doesn't believe in God, he believes that 'holiness' will set you free." When the interviewer asks her what she means by "holiness,"

she replies that for Bergman "great art, in those rare moments when you achieve something special, approaches holiness. Of course, I am volunteering my interpretation. I am guessing that this is what he would say. That's not my view of life."[13]

With respect to Bergman's steadfast rejection of any possibility of life after death, the "problem" to which he alludes in his statement about the chapel scene in *Saraband* poses further difficulties. What he says in the documentary about holding onto his desire to see again his wife Ingrid remains inconclusive there, though very relevant to the troubled father's speech in the film itself. But in a 2004 interview he elucidates his sentiment in words that elevate it into a significant affirmation. Describing the "devastating" consequence of losing Ingrid, he reports: "I feel Ingrid's presence, especially here on Farö. I feel it acutely. And I think: I can't feel her presence if she doesn't exist, can I? ... In true death, it might simply be that Ingrid is waiting for me and that she exists. And she'll come to meet me. I accept that I'm going to meet Ingrid. And I've completely crossed out that other nightmare thought that I'll never again meet her."[14]

Bergman's assertions about the holiness of man and his own acceptance of the idea that he and Ingrid will meet some day are both related, I believe, to Uncle

Jacob's conception of the mysterious immensities that surround us. If only as feelings that confront our evident mortality, they are views that many people hold. They are comparable to what Albert Einstein had in mind when he stated that "the most beautiful thing we can experience is the mysterious. It is the source of all true art and science."[15] Neither Einstein nor Bergman explains exactly what this means, however, or how the inferential leap from the first sentence in Einstein's formulation to the second can be justified.

But that is a task to which philosophers and theologians must devote themselves. In its totality Bergman's achievement, like Einstein's, can and should be recognized as inspirational in many ways. Above all, it may induce us to undertake what lies beyond the tentative speculations of these two great men, creative and admirable as they were despite their limitations. Where such needed undertakings will lead us, if anywhere, remains unforeseeable.

Notes

Preface

1. "Playboy Interview: Ingmar Bergman. A Candid Conversation with Sweden's One-Man New Wave of Cinematic Sorcery," *Playboy* 11, no. 6 (June 1964): 66.

2. Ingmar Bergman, *Images: My Life in Film*, trans. Marianne Ruuth (New York: Arcade, 1994), 83.

3. For instance, see "Ingmar Bergman," in *Conversations with the Great Moviemakers of Hollywood's Golden Age at the American Film Institute*, ed. George Stevens, Jr. (New York: Knopf, 2006), 641–642.

General Observations

1. John Simon, *Ingmar Bergman Directs* (New York: Harcourt, Brace, Jovanovich, 1972), 41.

2. Quoted in Roger Ebert, "On the Set with Ingmar Bergman," *Chicago Sun-Times*, January 1, 1975.

3. Richard Corliss, "Last Roar from a Legend," *Time*, July 10, 2005.

4. See "Of Winners and Losers: A Conversation with Ingmar Bergman," in Ingmar Bergman, *A Project for the Theatre*, ed. Edward J. Marker and Lise-Lone Marker (New York: Ungar, 1983), 15.

5. On Whitman and film, see Ben Singer, "Connoisseurs of Chaos: Whitman, Vertov and the 'Poetic Survey,'" *Literature/Film Quarterly* 15, no. 4 (Fall 1987): 247–258.

6. Simon, *Ingmar Bergman Directs*, 16.

7. *Bergman on Bergman: Interviews with Ingmar Bergman by Stig Björkman, Torsten Manns, Jonas Sima*, trans. Paul Britten Austin (New York: Da Capo, 1993), 41.

8. Bergman, *Images*, 248.

9. Bergman, *Images*, 51.

10. "An Interview with Ingmar Bergman," *The Ingmar Bergman Collection*, MGM DVD, 2004.

Chapter 1 Magic, Myth, and the Return to Childhood

1. For further discussion of Sturges's work, see the chapter on *The Lady Eve* in my forthcoming book *Cinematic Mythmaking: Philosophy in Film* (Cambridge, MA: MIT Press, 2008).

2. *Talking with Ingmar Bergman*, ed. G. William Jones (Dallas: SMU Press, 1983), 28.

3. *Four Screenplays of Ingmar Bergman*, trans. Lars Malmstrom and David Kushner (New York: Simon and Schuster, 1960), 229.

4. *Four Screenplays of Ingmar Bergman*, 259.

5. "Filming, Part 2," *Ingmar Bergman Makes a Movie*, Criterion DVD, 2003.

6. "Filming, Part 2," *Ingmar Bergman Makes a Movie*.

7. See Bergman, *Images*, 238.

8. "Filming, Part 2," *Ingmar Bergman Makes a Movie*.

9. Ingmar Bergman, *The Magic Lantern: An Autobiography*, trans. Joan Tate (New York: Penguin, 1988), 243. For further discussion, see also my book *Mozart and Beethoven: The Concept of Love in Their Operas* (Baltimore: Johns Hopkins University Press, 1977), particularly 111n.

10. *Talking with Ingmar Bergman*, 31.

11. On this, see my book *Feeling and Imagination: The Vibrant Flux of Our Existence* (Lanham, MD.: Rowman and Littlefield, 2001).

12. August Strindberg, *"A Dream Play" and Four Chamber Plays*, trans. Walter Johnson (New York: Norton, 1974), 19.

13. *Talking with Ingmar Bergman*, 49, 66.

Chapter 2 Religious Quandaries and the Nature of Love

1. *Talking with Ingmar Bergman*, 30–31.

2. Bergman, *Images*, 235–236.

3. See Jesse Kalin, *The Films of Ingmar Bergman* (Cambridge: Cambridge University Press, 2003), 191–202.

4. Interview in "Man Alive," Canadian Broadcasting Company, 1970, in *The Ingmar Bergman Collection: Supplemental Materials*, MGM DVD, 2004.

5. *Bergman on Bergman*, 172–173, and Bergman, *Images*, 244–245. The wording Bergman later repudiated appears in an introductory note in Ingmar Bergman, *A Film Trilogy: Through a Glass Darkly, The Communicants (Winter Light), The Silence*, trans. Paul Britten Austin (New York: Orion, 1967). It reads: "The theme of these three films is a 'reduction'—in the metaphysical sense of that word. THROUGH A GLASS DARKLY—certainty achieved. THE COMMUNICANTS—certainty unmasked. THE SILENCE—God's silence—the negative impression."

6. Bergman, *Images*, 248–249.

7. Bergman, *Images*, 274. The wording is slightly different in Bergman, *The Magic Lantern*, 273.

8. *Four Screenplays of Ingmar Bergman*, 17–18.

9. *Talking with Ingmar Bergman*, 58.

10. *Talking with Ingmar Bergman*, 58.

11. *Talking with Ingmar Bergman*, 61.

12. Bergman, *Images*, 190.

13. Nigel Floyd, *Time Out*, available at www.Bergmanorama. com.

14. Peter Cowie, *Ingmar Bergman: A Critical Biography* (New York: Scribner's, 1982), 155.

15. *Talking with Ingmar Bergman*, 63.

16. *Talking with Ingmar Bergman*, 63.

17. *Bergman on Bergman*, 227.

18. For this quotation, I have mainly used the film version. A variant translation of the stage version, together with the rest of the play, appears in Bergman, *A Project for the Theatre*, 213–215 in particular.

Chapter 3 Ambiguities of the Human Condition

1. Bergman, *Images*, 64, 65.

2. Bergman, *Images*, 306.

3. Bergman, *Images*, 214.

4. Bergman, *Images*, 215.

5. Bergman, *Images*, 214.

6. On this, see Robin Wood, *Ingmar Bergman* (New York: Praeger, 1969).

7. "The Making of *Saraband*," *Saraband*, Criteron DVD, 2003.

8. Bergman, *Images*, 97.

9. Bergman, *Images*, 99.

10. Bergman, *Images*, 362.

11. Bergman, *Images*, 380.

12. Bergman, *Images*, 366.

Epilogue

1. "Ingmar Bergman on Life and Work," documentary by Jörn Donner in DVD of *Wild Strawberries*, Criterion, 2002.

2. Marc Gervais, *Ingmar Bergman: Magician and Prophet* (Montreal: McGill-Queens University Press, 1999), 234–247.

3. Ingmar Bergman, *Private Confessions: A Novel*, trans. Joan Tate (New York: Arcade, 1997), 31–32.

4. Interview in "Man Alive," in *The Ingmar Bergman Collection*.

5. Bergman, *Private Confessions*, 159.

6. Jean Béranger, "Meeting with Ingmar Bergman," in *Focus on "The Seventh Seal,"* ed. Birgitta Steene (Englewood Cliffs, NJ: Prentice-Hall, 1972), 13.

7. Bergman, *Images*, 241.

8. Bergman, *Private Confessions*, 105.

9. Bergman, *Private Confessions*, 24.

10. Bergman, *Private Confessions*, 98.

11. Gervais, *Ingmar Bergman*, 245.

12. See earlier, p. 127 (Bergman's italics).

13. Richard Porton, "Actress behind the Camera: An Interview with Liv," in *Liv Ullmann Interviews*, ed. Robert Emmet Long (Jackson: University Press of Mississippi, 2006), 209.

14. *Bergman Island*, Svensk Filmindustri documentary, 2004, 2006.

15. Albert Einstein, in *Living Philosophies* (New York: Simon and Schuster, 1931), 6.

Index